Solving the Mystery
of Watercolor

DAVID TAYLOR AND RON RANSON

international
artist

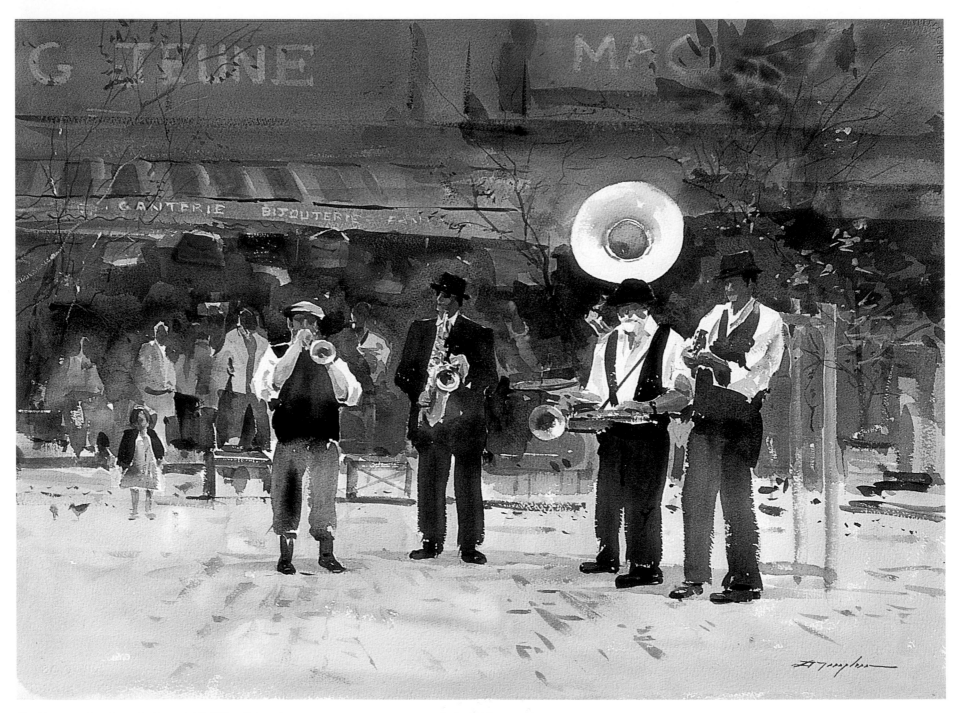

Strike up the Band, 21 x 30" (53 x 76cm)

Solving the Mystery
of Watercolor

DAVID TAYLOR AND RON RANSON

international
artist

international **artist**

International Artist Publishing, Inc
2775 Old Highway 40
P.O. Box 1450
Verdi, Nevada 89439
Website: www.international-artist.com

© David Taylor

Edited by Terri Dodd
Designed by Vincent Miller
Typeset by Cara Herald and Ilse Holloway

ISBN 1-929834-20-9

Printed in Hong Kong
First printed in hardcover 2002
06 05 04 03 02 6 5 4 3 2 1

Distributed to the trade and art markets
in North America by:
North Light Books,
an imprint of F&W Publications, Inc
4700 East Galbraith Road
Cincinnati, OH 45236
(800) 289-0963

Acknowledgments

This book was written under very unusual
circumstances — the artist lives in Australia
and the writer lives in England. It is entirely due
to David Taylor's great patience and enthusiastic
cooperation that the book was completed.

I wish to express my gratitude to Vincent Miller,
the Publisher. I'd like to thank Ann Mills for
the enormous help she has given me in the
production of this book and, finally, my dear
wife, Darlis, for her endless patience in typing
every word.

— Ron Ranson

**Still Morning, Weymouth,
14 x 21" (36 x 53cm)**
*The predominantly cool colors of this picture give the
impression of early morning before the sun has risen.
The warm colors of the building on the right, and
the touches of orange and red heighten this effect.
The reflections in the water have been handled with
great subtlety and economy of stroke.*

Foreword

For some years now I have taught in Australia touring different states and cities. On one occasion I was in Melbourne and the organizer of the workshop hosted a party for me to which he invited all the top artists in the Melbourne area. It was a great evening and there was a tremendous sense of camaraderie. I soon became aware that I had been introduced to a nucleus of world-class watercolorists. In my travels around the world I haven't before encountered so much talent in one small area. David was one of the artists I met that night

and we immediately formed the beginning of a friendship that has been close and lasting.

David invited my wife and I to his home where his paintings thrilled me to bits. My immediate reaction was to say, "I want to write a book about you". I was so excited by the prospect that then and there I started on the sketches and layouts. David and his wife Diana, a fine oil painter and teacher in her own right, already had several of my earlier books between them, so they too were enthusiastic. Due to circumstances of distance and time it has

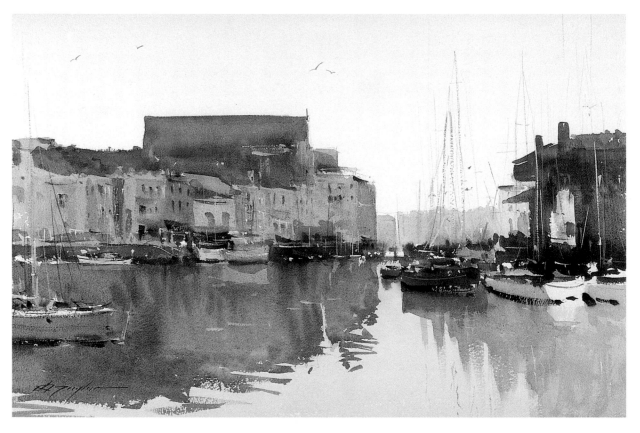

taken us several years to actually produce the book. We were greatly encouraged in this by Vincent Miller, a great entrepreneur and the publisher of *International Artist* magazine, *Australian Artist* magazine, *Pastel Artist International* magazine and many books by such artists as Harley Brown, Tom Lynch, Alvaro Castagnet, Robert Wade, Ramon Kelley and Robert Lovett.

Australia's history of impressionism dates back to 1885 when the Heidelberg School was formed — the first great flowering of Australian art. A number of young, intensely nationalistic painters gathered together to evolve their own truly Australian impressionism, producing a new and different kind of painting that has shaped Australian vision ever since.

I truly believe that the enthusiasm and support experienced by that early group is being repeated now in Melbourne. Since I was last there many members of the group have become known throughout the world, including David. The last two or three years has found him teaching and painting all over Europe, and he will soon be teaching workshops in the United States of America.

Although I have written many books over the years, my greatest joy has been bringing to the attention of the worldwide public, artists whom I have greatly admired.

David has already achieved so much, but I know that even greater things lie ahead. I hope that this book will contribute to his fame throughout the world.

— *Ron Ranson*

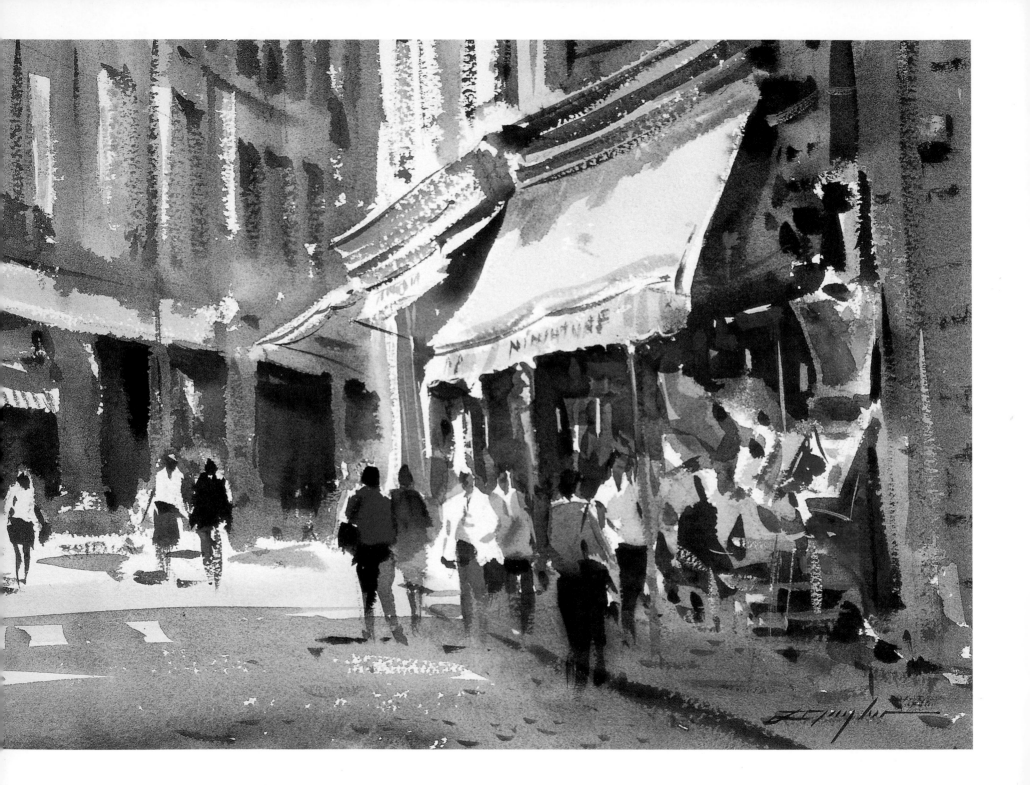

David's paintings here are almost exclusively done *en plein air* — worked in the field, where you are moved by the immediacy of the subject to take a very fresh, urgent approach to capturing the scene on paper. Once you have mastered the technique of working boldly and loosely out of doors you can transfer that verve to your studio work. In other words, the more you work on the spot the better and more confident your studio paintings will be.

Watercolor is ideal for working out of doors, and its free flowing qualities are so suited to capturing the fickle movement of light, which changes at each moment. When you put a wash down on damp paper you're constantly surprised at what emerges. It often results in chance often unpredictable effects. Sometimes the most exciting effects are the result of accidents that can be induced but never really planned beforehand.

Just being relaxed will not necessarily produce loose watercolors because you also need to feel really excited about what you're going to do. For instance, I've watched David producing a painting and his excitement is so great that he often does a few small jumps in the air — perhaps it pumps the heart and clears the head.

You'll also need good drawing skills to sketch your subject in with a few lines, saying a lot with very little. The adrenaline needs to flow so that your hand can rapidly transmit the information your eye sees to the paper with a line that has life.

Basically David's painting aims always to leave something to the viewer's imagination, while at the same time endeavoring to convince them that what they do see is real.

Finally, may I say that this book has not really been produced for the total beginner, and a certain level of skill is assumed. Rather is it for the intermediate painter who has reached the stage where they will really benefit from a close study of

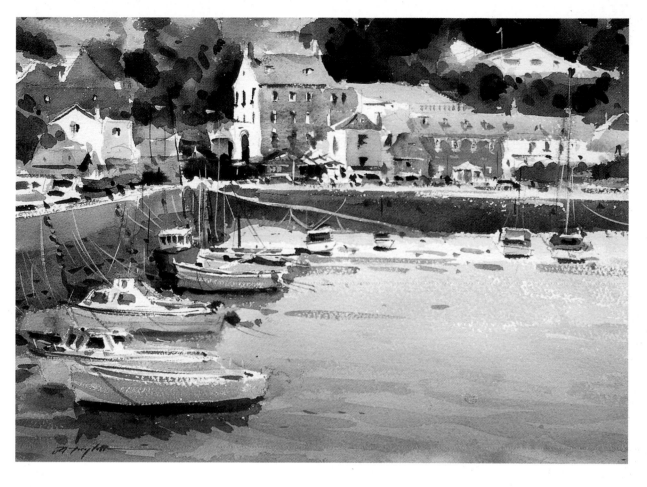

the work of a top professional. The purpose of this book is rather like a master class, to hone your already acquired knowledge and skill to a further stage. My aim as the writer of this book, is to analyze David Taylor's paintings throughout, and try to uncover the thought processes involved behind the brush. I feel, any watercolorist, just looking at the paintings can't help but receive a shot of adrenaline and inspiration, but I'd really like you to go through the book carefully, page by page, absorbing the deeper meaning of David's watercolors, and by doing so take a giant stride in solving the mystery of watercolor.

The Harbor at St. Peter Port, Guernsey, 11 x 15" (28 x 38cm)

This painting is full of sparkling contrast, the rich, dark, wet-into-wet greens picking out the sharp profile of the buildings. A lot of activity on the quay is hinted at with a minimum of strokes. Look at the way the tone of the sea has been gradated to give recession.

Materials and techniques

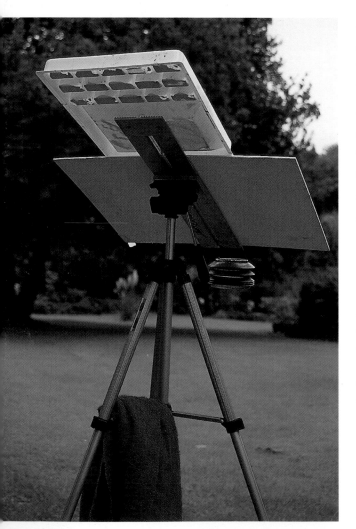

Unfortunately, spending a fortune on materials in art shops doesn't turn us into good artists, yet we all do it, feeling that a certain brush, color or paper will transform our work and allow us to produce a masterpiece overnight. In fact, the finest artists are often those who use the fewest and simplest materials. It is only natural that we should be interested in what our favorite artists use, so here you'll find David's own tools. As well, most of David's paintings are done on site, therefore we're showing his outdoor equipment, much of which he has either adapted or designed himself, including his own lightweight palette and working easel. Then, on the following pages, you'll see his straightforward, simple techniques.

David based the design of his outdoor easel on a commercially produced photographic tripod. The attachment holds his backing board and palette, together with his collapsible water pot. Another essential is a towel, which he always carries with him when painting outdoors.

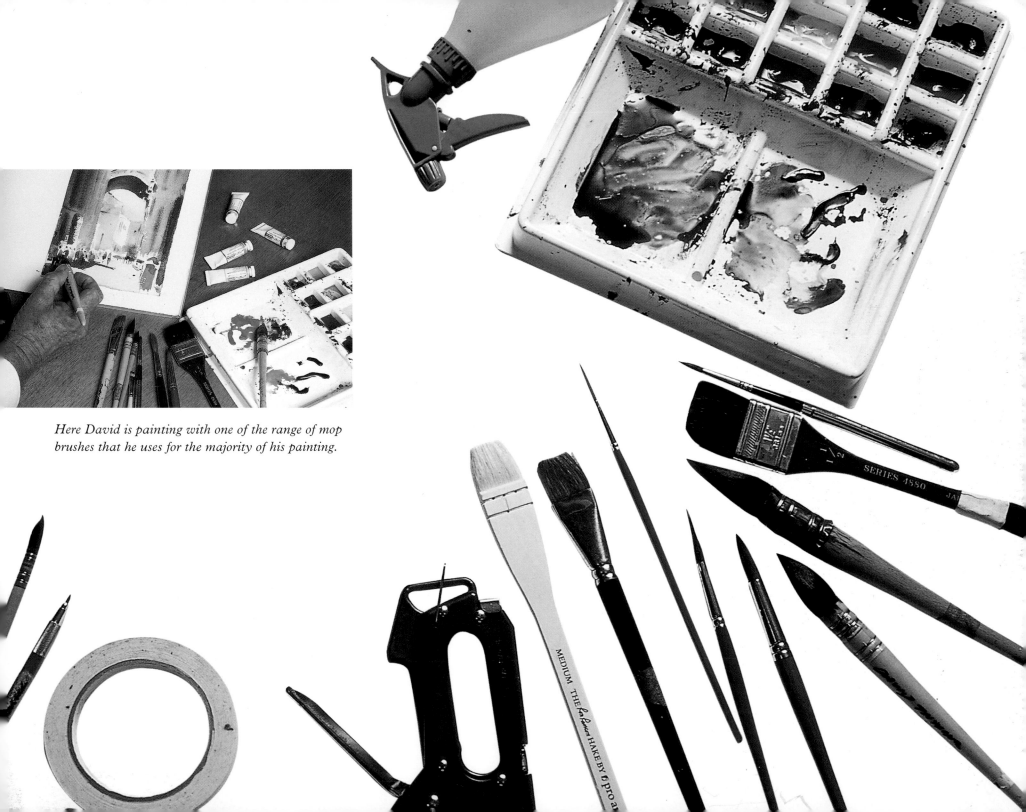

Here David is painting with one of the range of mop brushes that he uses for the majority of his painting.

The Materials

Brushes

David has a collection of large and small Raphael mop brushes which he uses for the majority of his painting. These are French and are made of gray squirrel hair. They are soft when dry, but point beautifully when wet. I wrote a book some years ago about Edward Wesson, a great English watercolorist who started buying French mop brushes just after the war. They were called French Polishers Mops and were not originally intended for fine art. He became famous for using them and they greatly influenced his free brush techniques. These brushes quickly caught on among his students and they are now used by artists throughout the world, often in preference to the much more expensive sables. They don't have the spring of sable, but their very floppiness imparts a sense of freedom, and many of the strokes can be made quickly, using the side of the brush.

For detail work, David uses a few small pocket and rigger brushes. For angled shapes and buildings he uses some flat sable blend brushes. Finally, for backgrounds he uses a hake and a very large wash brush.

Paper

David likes to experiment with various papers for special effects, but he predominantly uses Arches 180gsm and 300gsm in rough and cold pressed form, and 300gsm in the smooth hot pressed form. He also, uses Saunders Waterford in 300gsm rough, occasionally Whatman's Lana, and also Bockingford papers.

Before starting to paint, David stretches his paper by thoroughly soaking it on both sides, then he uses a staple gun that fires staples into a thin board. When the painting is finished he lifts the staples with a small staple remover.

Colors

His colors are mostly Winsor and Newton artist quality tubes, some Holbein, and some Art Spectrum — an Australian company that specializes in providing particular colors to suit the Australian landscape. He says he normally uses no more than six or seven colors for any one painting. There may be an extra color thrown in to highlight an important focal point.

David's small palette, which he uses for all his outdoor painting, consists of 15 colors. These are:

Blues

Cerulean Blue
Cobalt Blue
French Ultramarine
Winsor Blue (green shade)

Yellows

Raw Sienna
Raw Umber
Aureolin
Cadmium Lemon
Cadmium Orange

Reds and Browns

Cadmium Red Deep
Brown Madder
Quinacridone Magenta
Burnt Sienna
Sepia

Greens

Hookers Green (or Viridian)

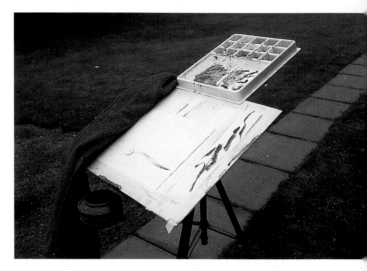

Another view of David's easel showing water pot and palette.

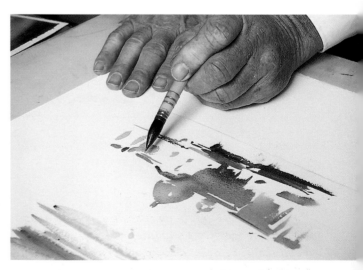

David using one of his range of mop brushes.

The Techniques

Dry Brush

When using dry brush, the most important thing is to use a minimum amount of pressure and commit the stroke with speed. This will ensure that the brush merely skims the surface of the paper leaving paint only on the top of the grain. It can be used to great effect in many ways, and you'll see David's use of the technique throughout the book. Naturally, this technique needs practice even though it looks very simple.

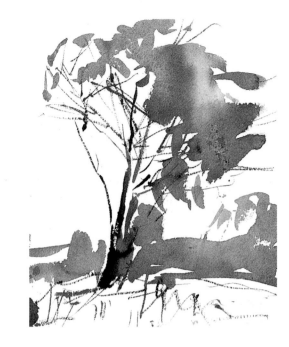

Wet-into-Wet

To use this technique, paint is applied to a still damp wash, allowing the color to fuse and blend. The second paint should be richer and stronger, with less water in the brush. If the paint is too thin on this second application there is a danger of back-run, or a cauliflower effect.

Wet-on-Wet

Here the paper is wetted thoroughly, and more water is left in the brush. It affords a wonderful chance of creating beautiful accidents — in fact, of letting watercolor do it's own thing! Try using two colors, one on one side of the brush, one on the other. Wet-on-wet is a technique tailor-made for painting skies, or any large expanse. The more often you use it, the more and better uses will be found for the technique.

Calligraphy

This is the delicate use of the long-haired rigger brush to produce such things as the finest of branches, reeds and grasses. Holding the brush at the top of the handle will produce a freer effect. Not the easiest thing in the world, but well worth practicing.

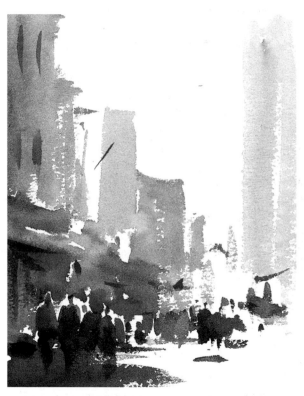

Lost and Found Edges

In this technique both dry brush and wet-into-wet can be used to obtain an effect where a hard edge gradually dissolves and is lost, creating an air of mystery and intrigue. It also avoids the cardboard cut-out effect and allows the viewer to use their imagination — more of this later.

Combining all the techniques in one street scene

Having introduced the various techniques, let's now show how they combine to produce a unified finished painting. This unity can be best achieved during the initial stages by regarding the buildings as simple blocks of color, which will later be decorated and brought to life by windows, doors and figures.

The wet-into-wet beginning

After the paper has been thoroughly saturated, the initial washes go in — the blocking in, which will hold the entire painting together. It is important at this stage to let the various warm and cool colors run together, as shown below. This will give the finished painting an overall glow.

The dry brush strokes in calligraphy

This is where the speed of the brush is important to give spontaneity to the whole painting. Using stronger and richer paint, a quick and light flick of the brush will provide the kind of vitality impossible to obtain with a slow, ponderous stroke. It is almost like shorthand.

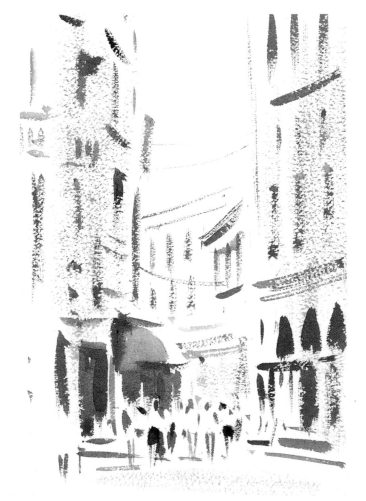

Shopping in Cortona, 15 x 11" (38 x 28cm)

The resulting painting exudes warmth and movement and the holiday makers are clearly enjoying themselves.

Combining the techniques

This where it all comes together. The fresh, free initial washes will glow through the dark areas and semi-details. The various techniques should come together joyously, each important in it's own way and yet interdependent on the others, like instruments in an orchestra.

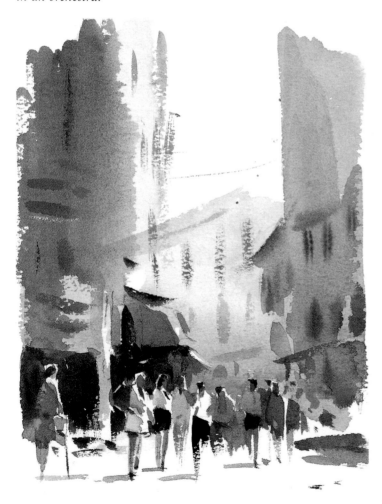

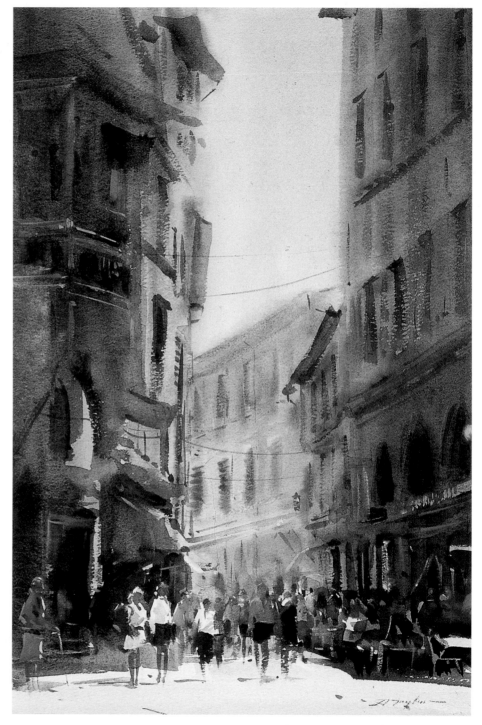

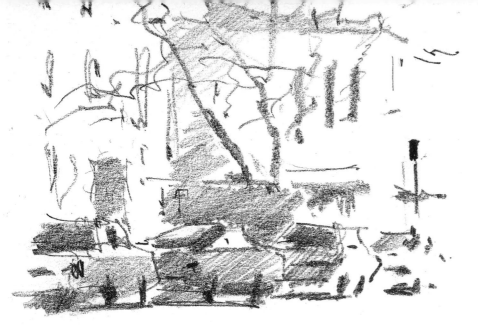

Cars should naturally blend

You can't ignore cars in street scenes, much as some of you would like to. Moving and parked cars are a fact of life so you might as well learn to draw them properly. First of all, they should form a natural part of the scene and not look as though they have been added on as an after thought. A row of parked cars forms a single unit and so they need not be drawn in separately. Don't worry about such things as wheels and ellipses — look at the cars on these two pages and you won't see any. Once you get the general proportions of the cars right, you are there. You can learn this by taking the time to make pencil sketches of them like the drawing at the top left. Do this for a few hours and they will soon become instinctive. Look through the book and you will see how simply and economically David has indicated his cars.

Draw in pencil
Pencil sketches like the one above can be done in minutes. Your cars will soon begin to look authentic. Paint dark shadows under the cars to hold them down.

Sketch in watercolor
Next try portraying quick little watercolor sketches, just concentrating on the cars, but without any details, whatsoever.

No details needed
Even in a finished painting, like this (shown again on page 79), only the general proportions matter — your viewer will imagine the details.

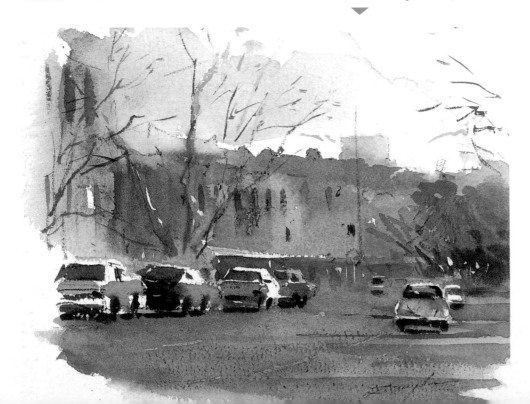

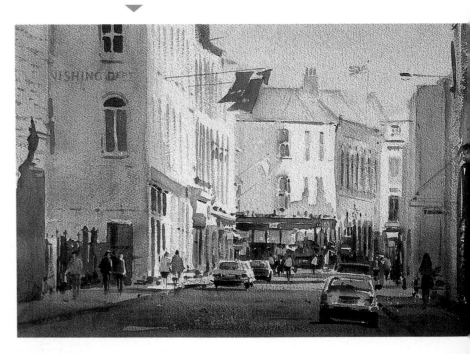

into your townscapes

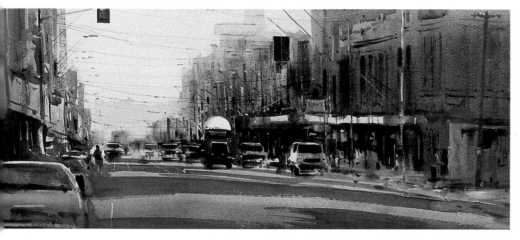

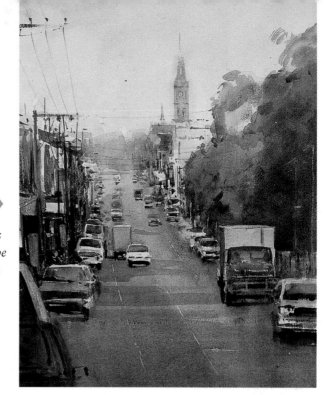

Less and less, further away
Only one or two cars in the front need to be in focus, the rest can be simply dots and dashes. The same theory applies with a group of boats.

Cars can show depth
Varying the size of the cars gives a tremendous sense of depth to the painting. Compare the foreground car to those in the far distance.

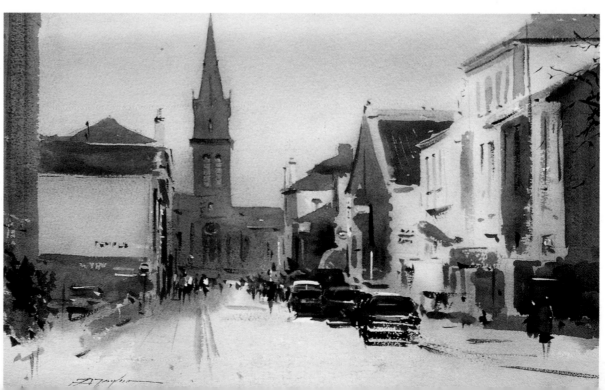

Blend your cars together
In this painting, the individual cars have been merged completely to give the impression of an entire group. The same illusion works for the figures at the back which seem to blend together.

Simple ways to paint boats

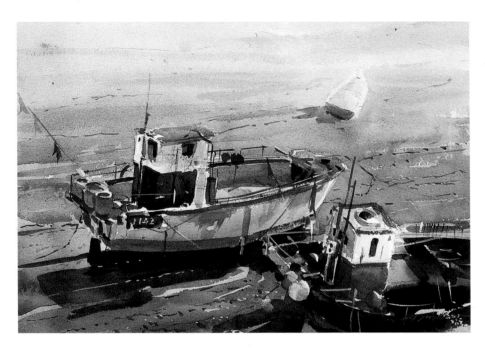

Boats are another problem area which causes unnecessary alarm and panic among otherwise perfectly competent painters. However, if you approach the subject in a logical way, boats are no more difficult to paint than anything else. Don't worry about small details, concentrate on the proportions. How far is the mast from the bow? How long is the cabin roof compared with the length of the boat? Just use your observation and

Forget boats — think pattern

If you were painting this picture, it would be as well to forget the word 'boat' and think of a pattern of shapes and tones. Look at the scene with your eyes screwed up and the pattern will emerge. Don't even think about the details until the very end.

The less strokes the better

This is a really elegant painting, and yet the composition is a collection of lights and darks adjacent to each other. It just goes to show how little detail you need to give a convincing impression. Note how the boats on the right have been counterchanged against the harbor wall. Similarly, the central foreground boat has been contrasted against the reflection of the wall. In the group on the left, individuality is lost, the boats being treated simply as a mass.

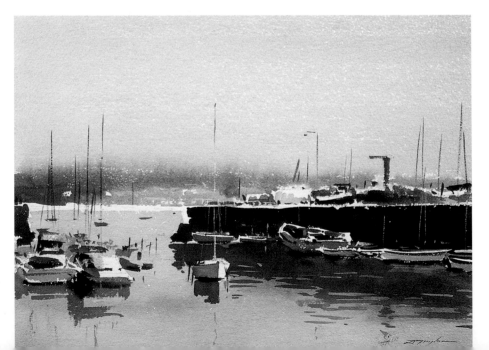

commonsense, and refuse to think of boats as being difficult!

If you're painting more than one boat, make sure they're not all the same size. Nothing looks worse, compositionally, than two boats of the same importance vying for your attention on opposite sides of a painting. Instead, make one more dominant than the other.

A word about the rigging on boats. To most of us this is just a confusion of ropes, especially if you don't know their functions. It's much better to leave most of it out of your painting than clutter the whole thing up. Put in the main lines of the rigging very lightly. A usual fault is to put in the ropes too thickly because of lack of brush control. With boats a good distance away, forget about rigging lines altogether rather than ruin your painting. Remember too that when boats are floating, most of the boat is under the water, so don't show too much above the surface, otherwise they end up looking like floating bathtubs.

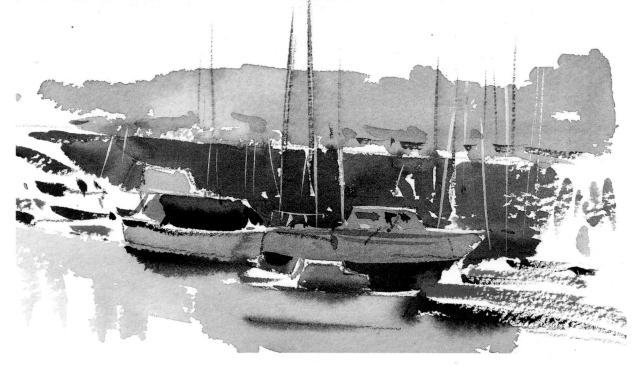

A 10-minute sketch of a group of boats.

A complex subject simplified

On the face of it, this is a very busy scene, but by using great economy of stroke it has been simplified without losing the general atmosphere. The buildings have been portrayed in flat tones and used mainly as a background to emphasize the boats. The cars in the background, while clearly being cars, have actually been reduced to a row of dots and dashes. What must have been many ropes has been reduced to a few.

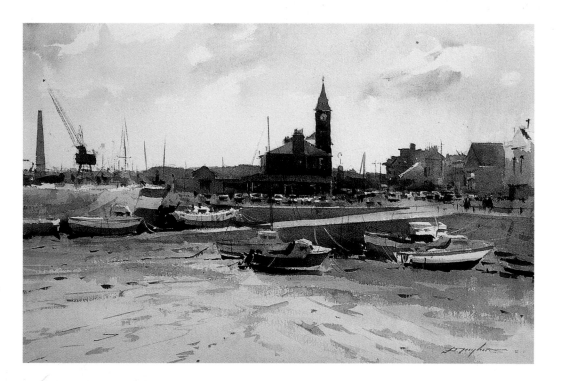

21

Confronting our fear of figures

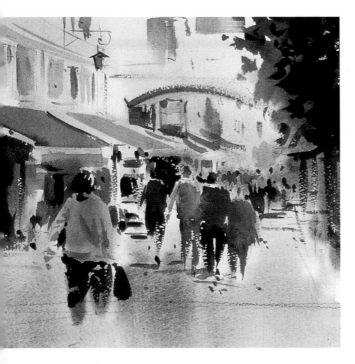

So many of us are afraid of adding figures to our paintings – afraid that we might ruin our picture. Unfortunately, this is often true. We've all seen figures in paintings that look more like garden gnomes, with huge heads and tiny bodies. However, we can't go on avoiding figures all our lives by painting street scenes at four in the morning, before anyone is up! The secret, as you will see from these illustrations, is not to paint figures too tightly, and to make them tall, with small heads and ignore the feet. Having got this basic knowledge firmly into your head, set out to practice. Draw first in pencil, perhaps while sitting in a parked car in a busy street, using your sketch pad and a soft pencil. Once started, you will be amazed at how quickly your confidence grows, and at how much more believable your figures will appear. You'll also find yourself handling them with a more casual approach, and making far less strokes.

Get the proportions right

Paint your figures with absolutely no detail at all. It's the general stance and freedom that counts. The four figures on the right have just one foot between them, and the lady on the left has legs that just disappear, but they are somehow believable.

Always counterchange

You need to counterchange your figures — light clothes against a dark background, as in the center, and dark figures against light backgrounds, as in the man on the right. Look at other street scenes throughout this book and you'll see many other examples of counterchange.

Draw with your brush

Here are a couple of gentlemen drawn very quickly just using a brush with no pre-pencil work at all. In general, the faster you produce them and the more you leave to the imagination, the more convincing figures look.

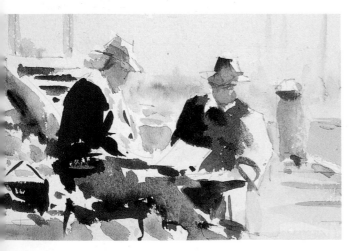

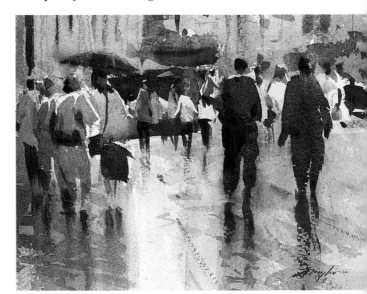

Practice your drawing

This is the kind of simple figure drawing you need to achieve with a soft 4B or 6B pencil, using both the point and side of the lead with quick strokes. The heads should be small, only about an eighth of the total height, and forget about feet!

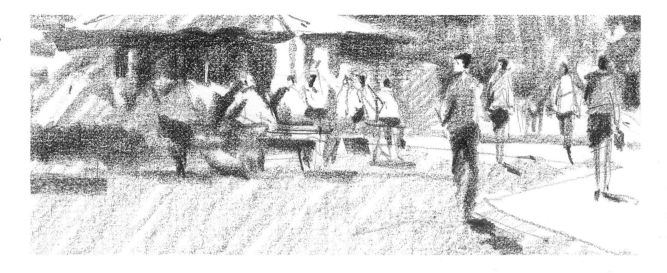

Keep the heads level

In a flat street scene such as this, notice how all the heads, whether near or far, are all on or about the same level. It's the legs that vary in height. Try drawing figures going into the distance and you'll see how it works.

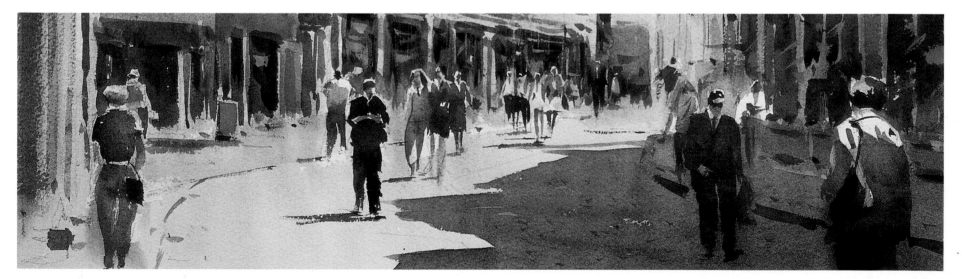

Varying techniques in a sunny beach scene

From the second David saw this Italian beach scene he knew it was going work. The hot sun sparkled on the sea, and the light pink roofs in the town stood out against the dark trees. The colors throughout the subject complemented each other and there was the added feature of all the life on the foreground beach. The two umbrellas were an important design factor. They were nicely contrasted against the darker tone behind them, and they also acted as a useful link between the foreground and the background. The eight colors David chose for the picture were Winsor Blue, French Ultramarine, Cadmium Orange, Cadmium Red, Raw Sienna, Cadmium Lemon, Brown Madder and Sepia.

The warm undertones

After the outlines were sketched in on Arches rough paper, the early tones of Raw Sienna, Cadmium Orange, and Cadmium Red were blocked in very lightly to create that high-key summer atmosphere. Then some accents of distant blue were added.

Adding the darks

After the warm tones were strengthened, background buildings and trees were added, many of them wet-into-wet, allowing the shadows to heighten the sunlit effect on rooftops and sides of the buildings. The two beach umbrellas were very important to emphasize and complement the warm tones. The cool colors of French Ultramarine, Winsor Blue, Quinacridone Magenta and Brown Madder were used.

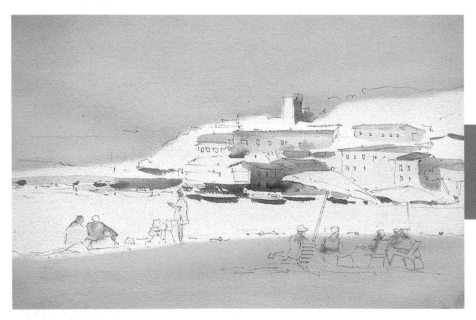
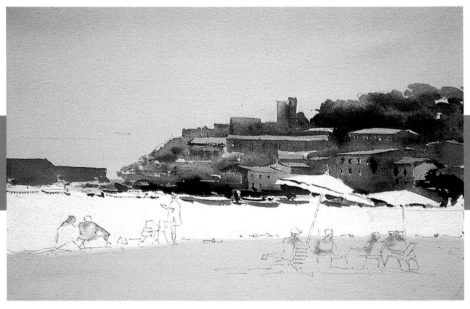

Finishing off with details

The chairs, figures and umbrellas were worked on using a rigger. Their strength certainly added impact and vitality, pulling it all together. The dark shadows and other details were added last.

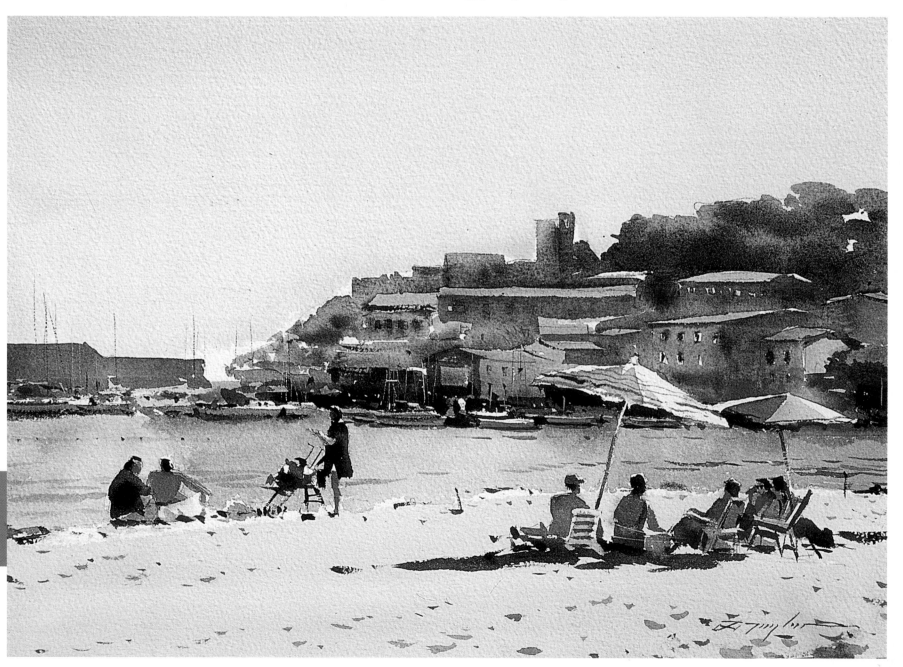

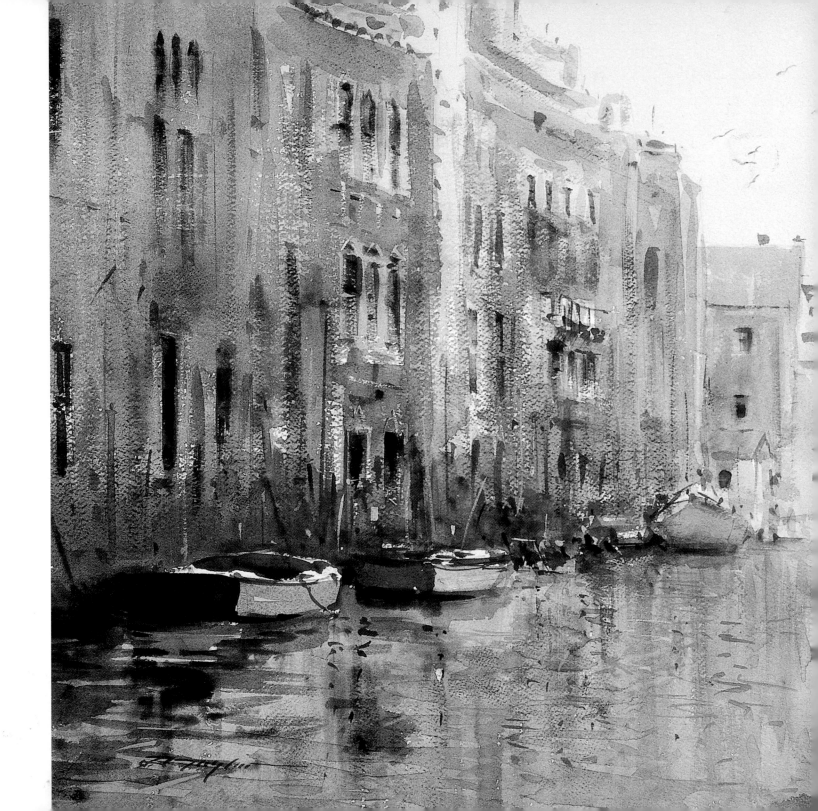

26

Composition

Composition is a part of the art of painting that none of us can afford to neglect — and yet we often do. Although our first instinct may be to look at a subject and paint exactly what is there, what we must remember is that nature is not in the business of design; design is the artist's responsibility. We may need to move, select, and reject objects if we are to end up with a satisfactory painting.

Fortunately, there are certain rules and principles which have been worked out for us, and that can help enormously when applied properly to the composition of a painting. This important process needs to be carried out before you take the paints out of their box. Although it's something we all attempt, it's virtually impossible to compose and paint at the same time.

One of the greatest artistic crimes we can commit is to bore our viewers. Good design will hold the attention. Remember, an artist is always an entertainer, just like a singer, actor or musician.

Idle Moments, Venice, 10 x 14" (25 x 36cm)
This is what I'd call a mood painting. In what is normally a bustling city, there is an air here of complete peace and quiet. As a composition it is well balanced, and the eye is taken into the picture along the canal. Entertainment is provided by the colors of the boats, while there is just enough detail to set off the simplicity with which the buildings have been indicated.

The eight principles of design

The eight principles of design are tools we can use to produce balanced compositions in which harmonious and varied shapes, tones, textures and colors create visual interest in all parts of the painting, while the principles of conflict and dominance are used to direct the viewer's attention to the most important features, so that they all come together in a unified whole.

It is said that amateurs paint pictures, while professionals build pictures with these bricks of knowledge. With them artists can think, plan, build, organize, express themselves and communicate. Let's look at the principles one by one.

1 Unity

Whatever you design on your paper must look like a complete unit rather than a collection of bits. What I'm saying is that an element that appears in one section of the painting should be echoed in another part so that all the sections are related. In musical terms, lack of unity could be expressed by playing a bar of "St. Louis Blues" in the middle of "Ave Maria". Unity can be achieved in many ways, for instance, a large foreground tree can be echoed by a small distant tree; a cloud shape can be repeated in a foreground bush; a large building can be echoed by a distant building.

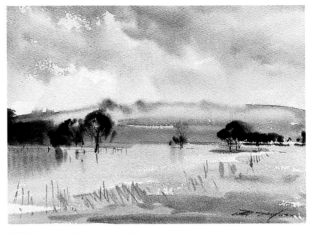

This picture has unity because it was painted spontaneously and wet-into-wet. No stopping and starting here! There's a wonderful flow about this work, and colors and shapes have been repeated throughout.

2 Conflict

While we can use gradation to prevent boredom in the less important areas of a painting, we can use conflict to generate excitement and interest, and to focus attention on the main subject. Conflict is created by placing opposites next to each other: a light next to a dark tone, a warm color against a cool one, a large shape next to a small one or a rounded shape next to an angular one, horizontal lines next to vertical ones, and so on. For example, if you want to emphasize a white building in a painting, no matter how small the building is, you can do this by placing a dark tree or some other dark shape behind it.

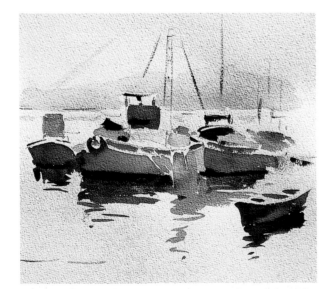

By placing red opposite green, and blue against yellow the attention is drawn to the main object of interest.

Here you see how conflict of tone draws attention to the cart. Leaving white paper around it emphasizes the effect.

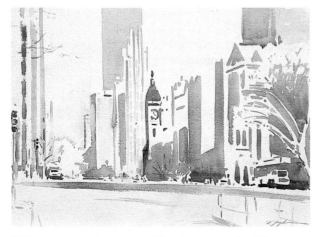

Here we see dominance of shape in the repetition of the awnings — the rest of the picture plays only a supporting role.

3 Dominance

Dominance is the most important aspect of designing a painting, and we need to think about it in relation to all aspects – shape, line, direction, texture, edge qualities, tonal values and color. It is vital because it makes clear what is most important in any painting. Of all the different types of shapes in your painting, one should be dominant; of the different types of lines, one should be dominant; there should be dominant direction, a dominant tone, a dominant color mood and a dominant texture.

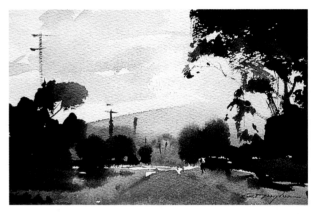

The dominant features are obviously the dark tones, with the mid-tones playing a subservient role.

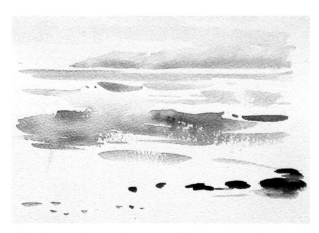

This is repetition of horizontal lines, but the shapes within those horizontals are varied in size and shape to prevent boredom.

4 Repetition

Repetition in art is used for several reasons. One is to unify and make the painting hold together. Another is to create visual rhythm so that the eye can enjoy a variety of interesting intervals between repeated shapes or colors. These shapes or colors must be varied, because without variation repetition is boring. For example, with a row of trees, some should be large, some small; make one or two grow at an angle and vary the colors. Once you begin to think about repetition, your imagination will supply an endless variety of repeats.

This painting shows repetition in the vertical lines of the buildings, but these are varied in length of line and tonal strength.

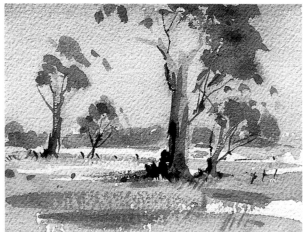

Alternation is achieved by the negative shapes between the trees.

5 Alternation

This is closely connected to repetition because it is what occurs between the repeats. Color alternation can consist of intense colors alternating between neutrals, or warm colors between cools. Alternation is simply a repeated interrelationship of sequences, rhythms in intervals between any of the design elements. It achieves unity with variety. It is a rhythmical sequence.

There is alternation in the use of color; warm and cool, intense and soft.

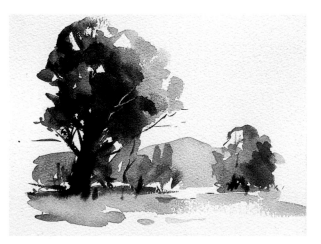

In this case the large boat on the left is balanced by the two smaller boats on the right.

6 Balance

One of the most important aspects of composition is balance. If a painting doesn't have a sense of balance it will look unsatisfactory, no matter what else you do. Unfortunately, nature doesn't present us with nicely balanced scenes, and it's always tempting just to paint a scene without thinking about balance. Balance is a way of making things look right. It's a matter of arranging features that are different in size, tone, color, shape and texture, so that they balance each other visually. For example, a large shape closer to the center of the picture can be balanced by a smaller shape farther out, close to the paper's edge.

The large tree mass near the center of the picture is balanced by the smaller one on the right.

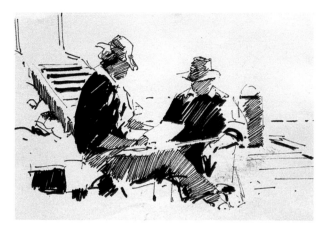

The subtle difference between the angles of the lines of shading lends a harmonious feel to this sketch.

7 Harmony

Harmonious elements in a painting are those that are similar. They are vital to our paintings because they can create interest in less important areas, while at the same time unifying the composition. Harmonious colors are close to each other on the color wheel, such as orange and red. Harmonious shapes are similar — a circle and an oval for example, or a square and a rectangle. Harmonious sizes are those that are close together. Straight and slightly curved lines are harmonious, as are close tonal values. In short, harmony is the opposite of contrast. Unlike contrast, harmony involves subtle, gentle changes that you can use to introduce interest into a subject.

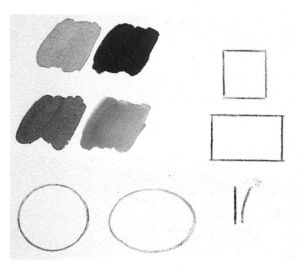

Illustrated here are various forms of harmony of color and shape.

8 Gradation

Gradation is the tool we use to add interest and variety in an area, large or small, without drawing attention to it through abrupt contrast. Yet, because gradation isn't always obvious in nature we often don't think about it when we are painting. We see green grass, or a brown shed, and that's how we paint it — all one color. But, if all areas of a painting are done with washes of flat color, the result is dull. So, to create interesting paintings, we have to use gradation, which basically means creating a gradual change — from a warm color to a cool one, or from a light tone to a dark one, from one type of line to another, or one size or type of shape to another.

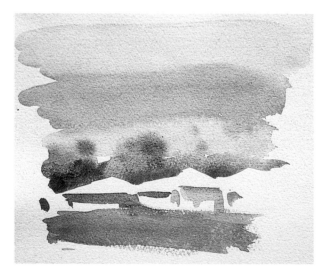

In this sketch we see the gradual change from cool to warm color together with the change from soft to strong.

Here we see gradation in the gradual change in the background from warm to cool color, while in the foreground we see a similar gradation in a rough, dry brush effect.

Applying the principles of design

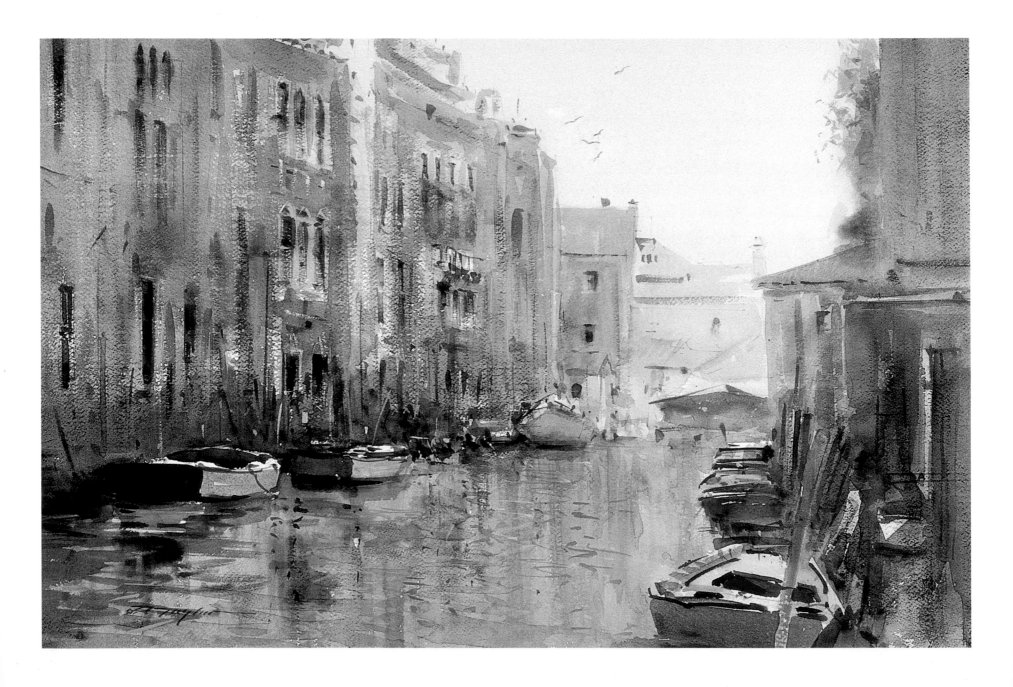

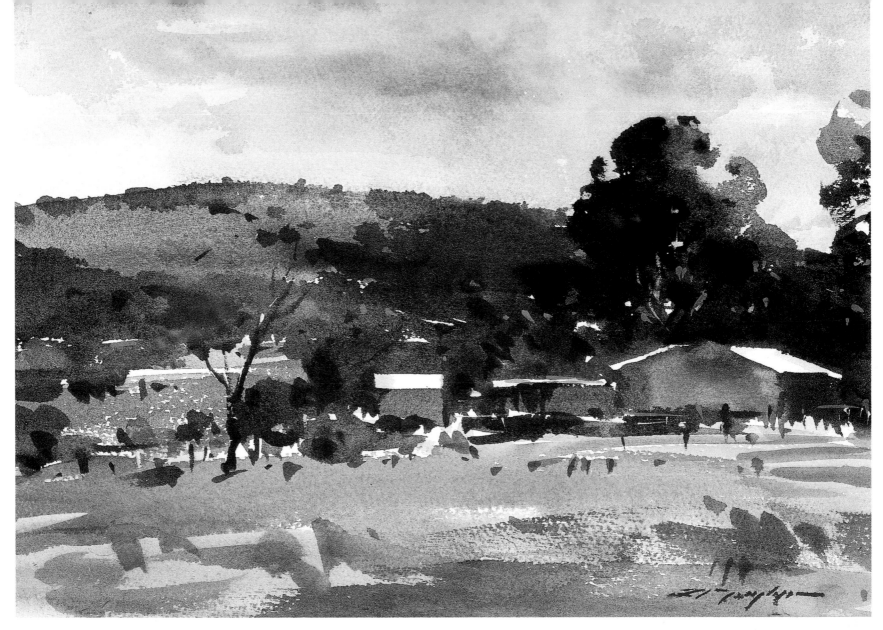

Afternoon Shadows, Mt. Martha, 15 x 22" (38 x 56cm)

David has made excellent use of conflict here. There is light against dark, opposing colors in the foreground field and the background trees, and light roofs against dark trees. The introduction of strong red into the largest building has made it the dominant feature. Gradation in the foreground field promotes interest, as does the variation in color in the background hills. Harmony is achieved by repetition of color in various parts of the painting.

Venetian Rythms,
14 x 20" (36 x 51cm)

Following design rules to create a fine composition

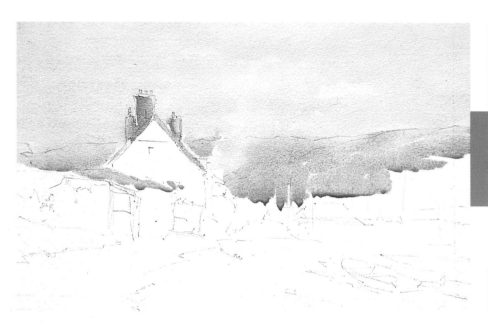

Porlock Weir is a magical spot in Somerset. It's an artist's paradise where you can wander around an area of a quarter of a square mile and find enough material for a hundred different paintings. You can then paint them quietly, without dozens of onlookers crowding around. However, this is where skill in composition is important. This scene, and the way it has been composed, followed all the rules. The main object, the cottage, is in the right place. The eye is taken into the painting via the path on the left of the cottage, which is the area of most contrast and color. Even the little dinghy on the right, while not competing for attention, is pointing to the focal point. There is plenty of harmony, gradation, and warm and cool color going on throughout the painting — a thoroughly satisfactory design!

Putting in the distant hills
David floated in the background hills in very soft, light washes of Cobalt and Raw Sienna, with stronger nuances of Cobalt and French Ultramarine around the lower extremities of the cottage roof line. The chimneys are included with washes of Burnt Sienna and a few additional touches of Quinacridone Gold added for the sunlight.

Moving forward wet-into-wet
The surrounding foreground is added wet-into-wet, making sure there is enough emphasis given to the fence, and also leaving enough white paper for dealing with highlighted areas later. The foreground washes are applied with strong, warm colors such as Raw Sienna, Aureolin, and Burnt Sienna. Magenta and French Ultramarine, and even a touch of Brown Madder are used for shadow areas while it is still wet.

Strong darks to finish off
The subject is pulled together using a good range of strong darks. There is no holding back, and they are applied spontaneously, using a range of Brown Madder, French Ultramarine and Burnt Sienna. Notice how the highlights sing.

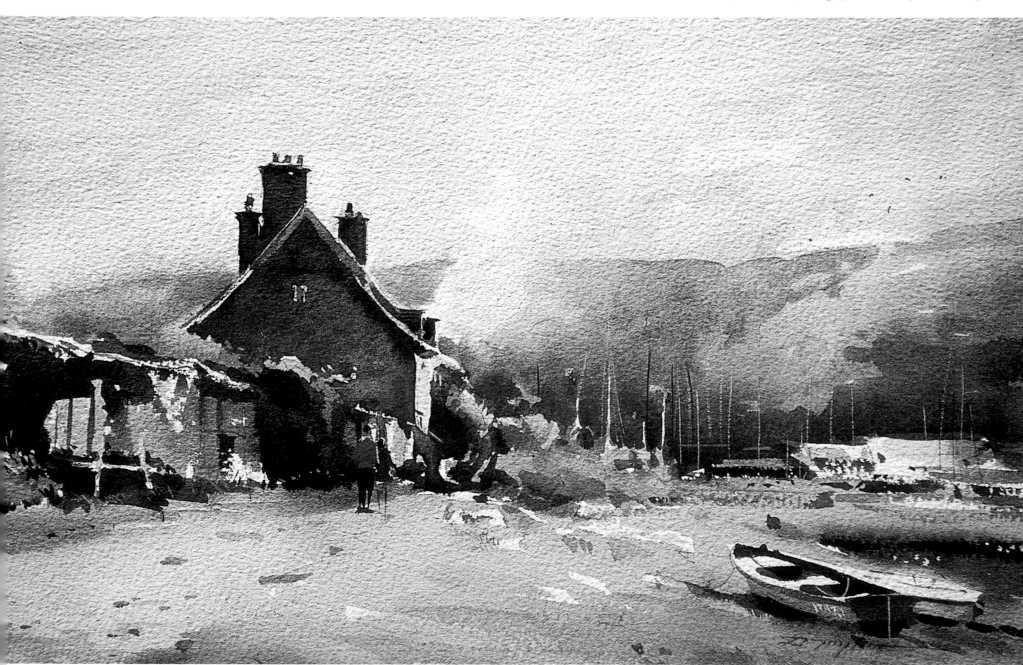

Establishing the focal point

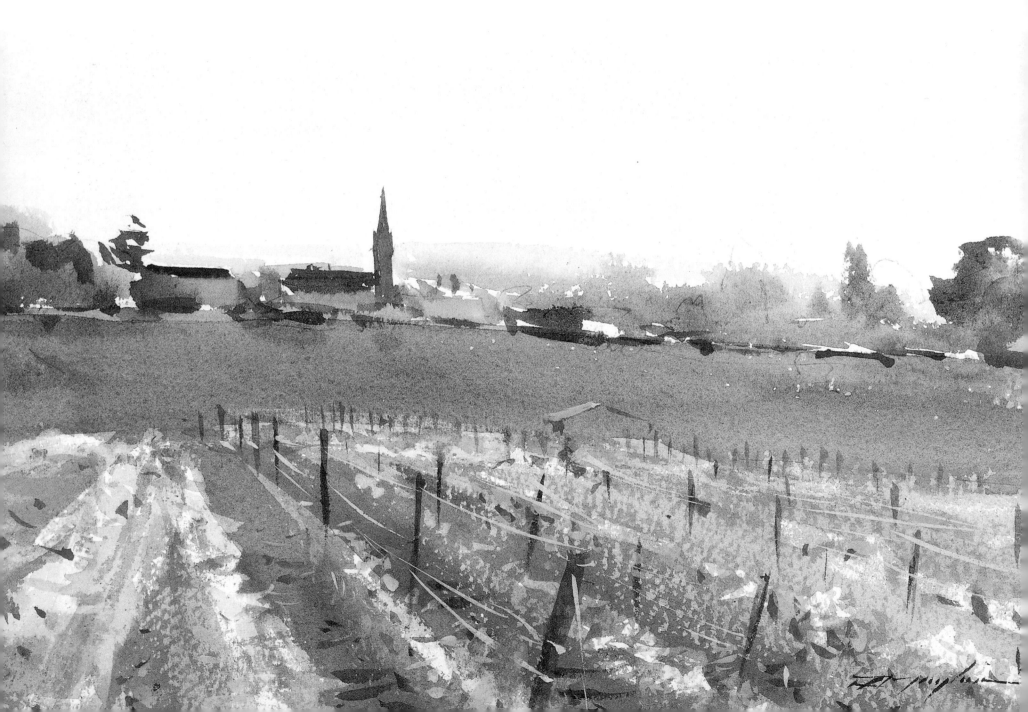

Vineyard in Beune, France,
11 x 15" (28 x 38cm)

This beautifully atmospheric painting exudes warmth and peace. The focal point is of course the church tower, which is the sharpest, most strongly contrasted part of the painting. It has been placed so that it is a different distance from each edge of the page, and the lines of vines and their posts combine to take the viewer's eye straight to the church. The background has been softened on the right, and this also accentuates the sharpness of the steeple. The whole painting is harmonious, while the touches of yellow help to enliven the scene.

Festival Time in St. Malo,
15 x 11" (38 x 28cm)

This painting was carried out in the late afternoon and the strong warm color of the tower establishes it as the main object of interest. The rich dark tones of the nearby buildings take the eye straight down the street towards the tower. The white umbrellas form an area of secondary interest but without competing with the dominant tower. The entire street scene is in shadow, with hardly any counterchanged figures to distract the eye. The complementary area of mauve next to the tower also enhances both the tower and the painting as a whole.

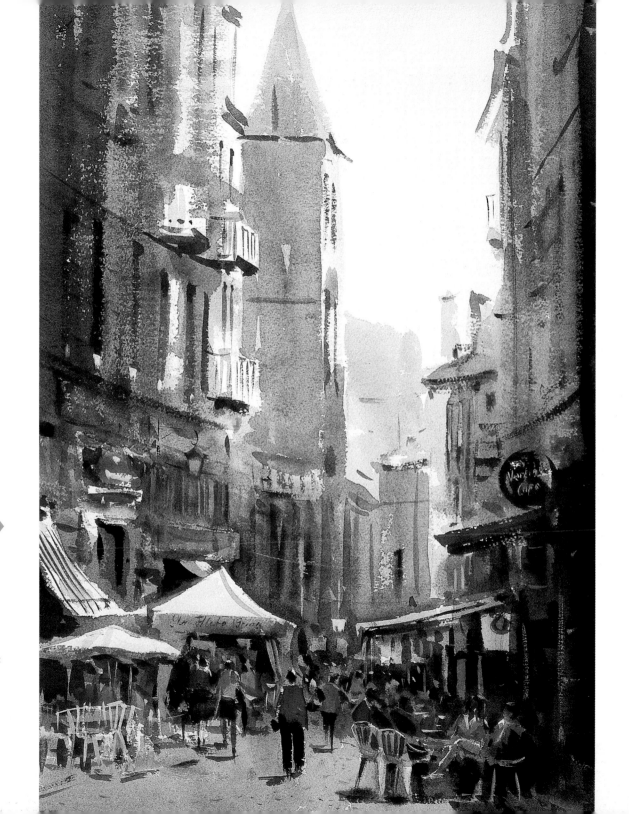

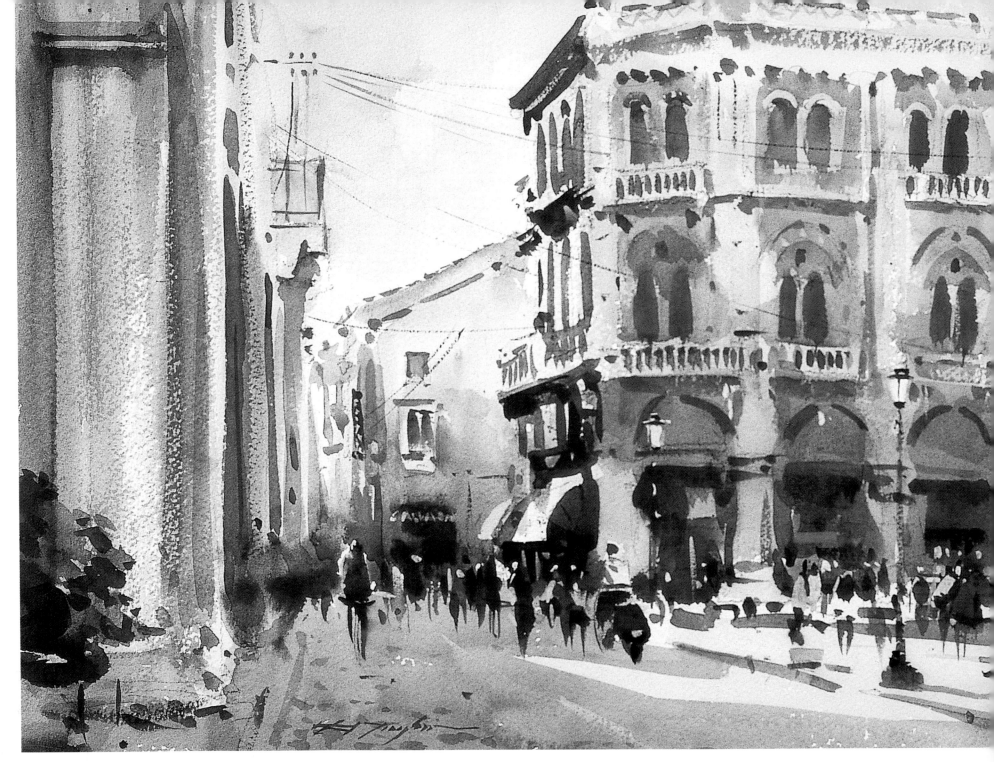

38

Light and Shade

The ability to see tonal values accurately is the single most important factor in watercolor painting. An untouched sheet of paper has just two dimensions, height and width. Our job as artists it to give the illusion of a third dimension, which is depth. This can only be achieved by thinking about the tonal value relationships.

It makes complete sense to produce a black and white sketch to work out the tonal values of your painting, even before you get your paints out. You can then start the actual painting with vastly more confidence, having already solved half the problems. At the same time you can make the design changes needed, eliminate unwanted details and build up a sense of drama. This sketch is of tremendous importance because it is the complete guide to your finished work. In it goes your entire thinking about what you wish to accomplish. A really good tonal value sketch can fill you with excitement and a real desire to paint, in color, the scene you produced in black and white.

Yesterday and Today, Padua,
15 x 22" (28 x 56cm)

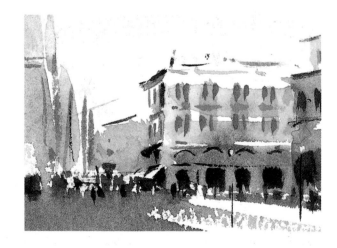

Painting on site may sometimes be more difficult than in the quiet of the studio, but can produce a more vibrant and lively painting. This one is dominated by the magnificent ancient architecture, which contrasts with the bustle of modern traffic. The cool gray of the columns on the left balances the warmth of the buildings across the street, while the light and shade provides drama throughout.

A closer look at creating tonal value sketches

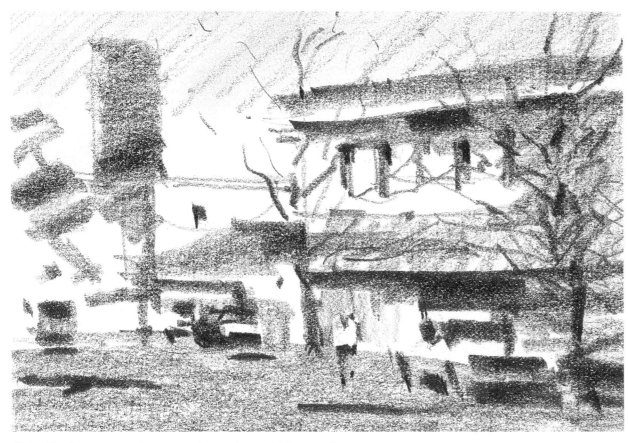

Being able to produce tonal value sketches in a professional way is almost an art in itself, and can be a joy for others to behold. You are able to concentrate on the problem in hand without distraction, producing a strong pattern with a wide range of tonal values. However, there is a strange reluctance by amateur artists to produce these sketches. They rush to do them quickly without much thought, eager to get on with the finished painting itself. As a teacher, I've often asked students to show me the preliminary tonal value sketch, only to be looked straight in the eye and told it has blown away!

The ability to achieve good, sound pencil technique for these sketches is actually gained very quickly once you get down to it, and the effort is enormously worthwhile.

While the drawings on the next few pages are done with pencil and graphite sticks, you can of

Probably the two most important factors in producing tonal value sketches are varied pencil pressure and economy of stroke. You're not aiming for any great detail, just for the overall pattern, and tonal value contrasts.

Carefully analyze this drawing and notice how much counterchange there is. The darkest darks have been achieved by putting maximum weight on the pencil. You'll see that these darks are often placed next to untouched white paper, which of course give the lightest lights. This drawing is mostly composed of areas of tonal value rather than outlines around everything, which I call "wire"! Try to quickly copy this drawing to achieve the simplicity and strength of the original.

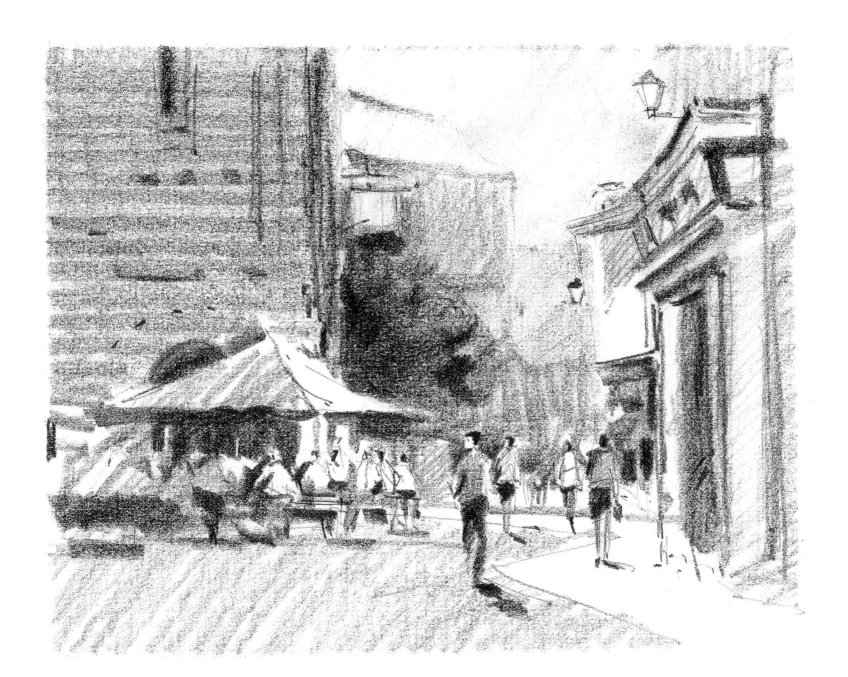

41

Holiday Atmoshpere, St. Malo,
3³⁄₄ x 4¹⁄₂" (10 x 12cm)

A tonal value sketch should give a vivid impression of how the final painting will appear. Correctly done, it will solve most of your problems before you start painting. Look at the figures in the foreground, and see how simply they have been indicated in the sketch with a few swift strokes of the pencil.

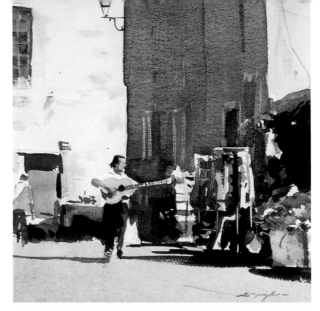

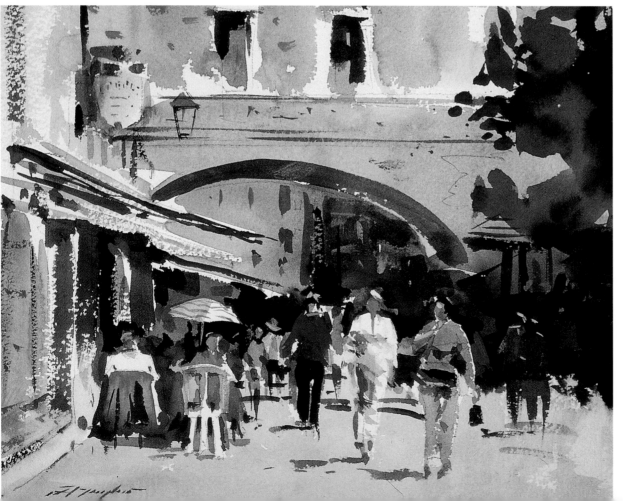

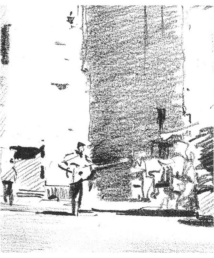

Street Musician, Carcassone,
10 x 14" (25 x 36cm)

This scene is about design, using strong shapes. Light and shade are very important here, but see how these have been worked out beforehand in the sketch. The painting is very evocative of the area. The musician and the lighting give an almost operatic atmosphere to the scene.

course use other materials such as gray and black chalks or sticks of charcoal. For these sketches you need a 9 x 12" bond paper pad, or what is known as a layout pad — don't use watercolor paper for sketches, it doesn't work. These papers have enough tooth to make dark lines, yet they are smooth enough to be able to lay large gray values with the side of your pencil or graphite stick. I always find soft 4B or 6B grades are best, because they allow for finger rubbing, which gives a certain subtleness and can't be achieved by just putting pencil to paper.

You'll also need a spray fixative to prevent smudging, especially if you are using charcoal or chalk.

Charcoal sticks can be very sensitive in use. Hold them very delicately when using the ends, but when you use the sides, put more pressure on and you can get instant darks.

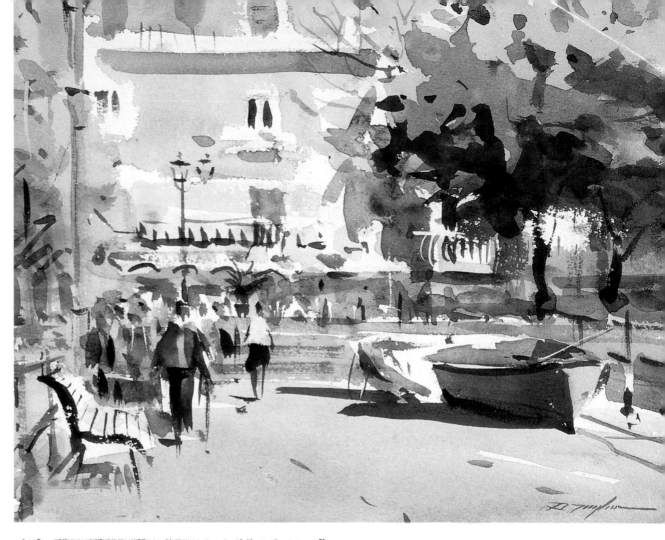

The Blue Boat, Minori, Amalfi Coast, 11 x 14" (28 x 36cm)

One of the first things I noticed about the preliminary sketch is how much has been achieved using strong darks and the merest flick of a pencil — yet everything that is essential to the final painting is here. When you begin the actual painting it's important to know exactly where you will need to leave the white paper untouched. Knowing this will give you more confidence.

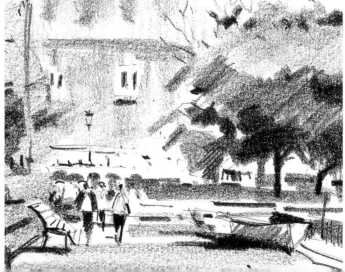

43

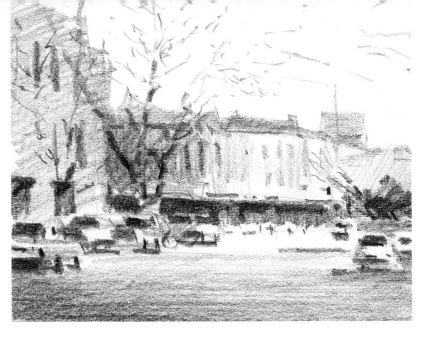

**Evening in Carlton, Melbourne,
14 x 21" (36 x 53cm)**

In the preliminary sketch on the right take particular note of the different techniques that David has used. There's a delicacy of line in the treatment of the trees, but there's a strong staccato way of using the pencil to indicate the cars. The whole sketch has been drawn with enormous restraint and economy, and yet it portrays the areas of light and shade needed for the finished painting.

Charcoal and chalk can be a little messy but they also produce very rapid results. There are no fixed methods for the production of these sketches, it's best to experiment to find what suits you best.

Don't worry about keeping your drawing too neat and tidy, this is a working diagram, not a finished work of art, and you can change anything as you go. Compose and change until you feel you've got the very best, most exciting design possible — then, and only then, get your paints out.

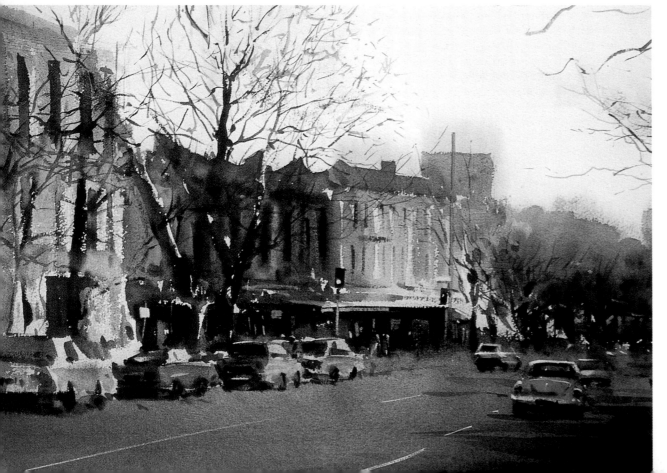

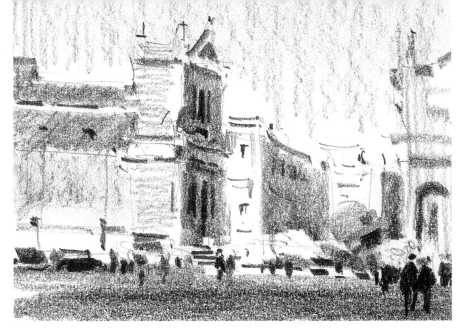

Basilica Bernardo Square,
8 x 10" (20 x 25cm)

*Here light and shade has been used in a very
dramatic way to portray this evening scene. Again
all the values have been worked out in the preliminary
sketch, with varying weights on the pencil. Much of
the work has been put in with the side of the pencil
— don't be afraid to try this, it will help you to avoid
putting in too much fiddly detail. Acquiring these
skills will eventually give you much pleasure. The
added bonus is that you can make sketches in a
busy street without attracting too much attention.*

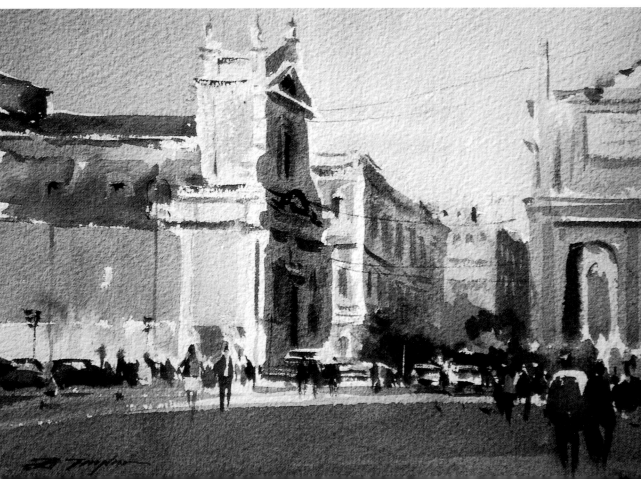

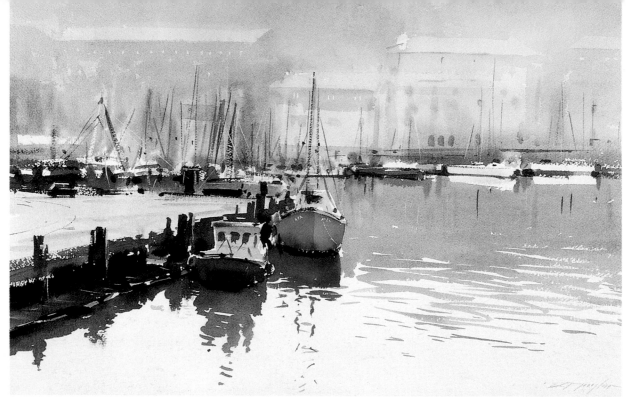

The Still and Quiet of Morning, Weymouth, 11 x 15" (28 x 38cm)

The importance of light and shade in a painting is perfectly expressed here. David has beautifully captured the sunlight on the foreground water, which is further enhanced by the strong reflections beneath the foreground boats. This is also an excellent example of using contrast to emphasize the lingering mist. The strong foreground contrasts with the high key buildings in the distance, while the color of the foreground water suggests the creamy sky above the mist.

Solitude, Tarentaal, 11 x 15" (28 x 38cm)

The line of light, counterchanged against the strong darks of the trees on the left, emphasizes even more the softness of the distance on the right. The reflections in the water have been handled beautifully, and with great restraint. The sharpness of the white roof gives impact to the scene, while the whole painting evokes the delicacy of a misty morning.

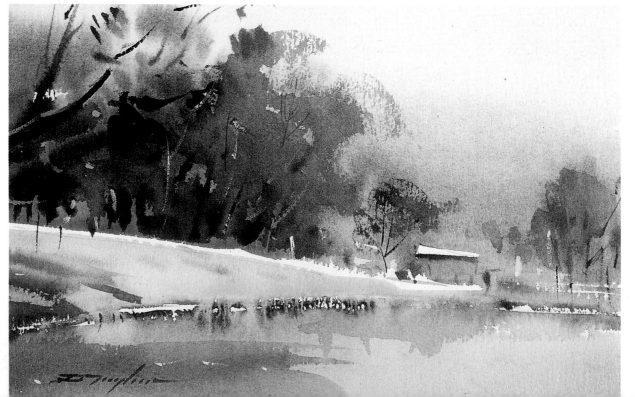

St. Peter Port, Guernsey, 11 x 15" (28 x 38cm)

At first glance, one gets an impression of an almost monochromatic painting, but it's really all about the subtle use of color and tone. Look carefully and you'll see yellows, mauves, browns and blues, all used with masterly sensitivity. The distant part of the town on the left has been merely hinted at, giving a misty quality, which contrasts well with the strong harbor wall.

Using light and shade to create a misty atmosphere

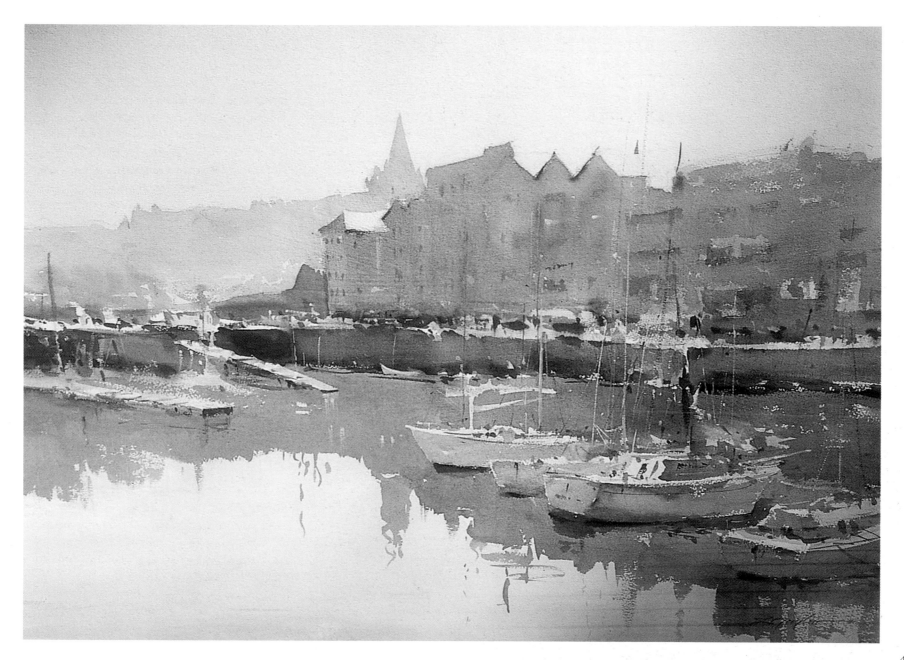

Using strong contrast to portray sunshine and shadow

Here David set out to create an entirely different atmosphere to that on the previous page. He had this to say about the painting. "The humidity hung in the air and the atmosphere was earthy and exciting. Here was the new and the old, modern day traffic and the horse drawn carriage sharing the same bustling city street. A feast of merging shadows and vibrant life! Lots of melting edges and silhouetted shapes, all waiting to be painted!" David painted this on 300gsm Torchon rough Arches paper.

The background was kept very wet, with warm colors such as Aureolin, Raw Umber and light touches of Magenta dropped in, then the cooler, deeper blues were added using Cobalt Blue and French Ultramarine; all the time making sure that the sharp edges at the bottom were retained.

Once the background wash was dry, David was able to begin putting in the sharper darks of the buildings, again being careful to preserve the white paper where necessary. The palette was kept quite simple with the addition of Sepia, leaving the vehicles and figures to be painted last.

The buildings and figures were put in with quick, vibrant strokes, with the shadows being added last. Notice how by not always allowing the washes to dry some of the shapes dissolve into these shadows.

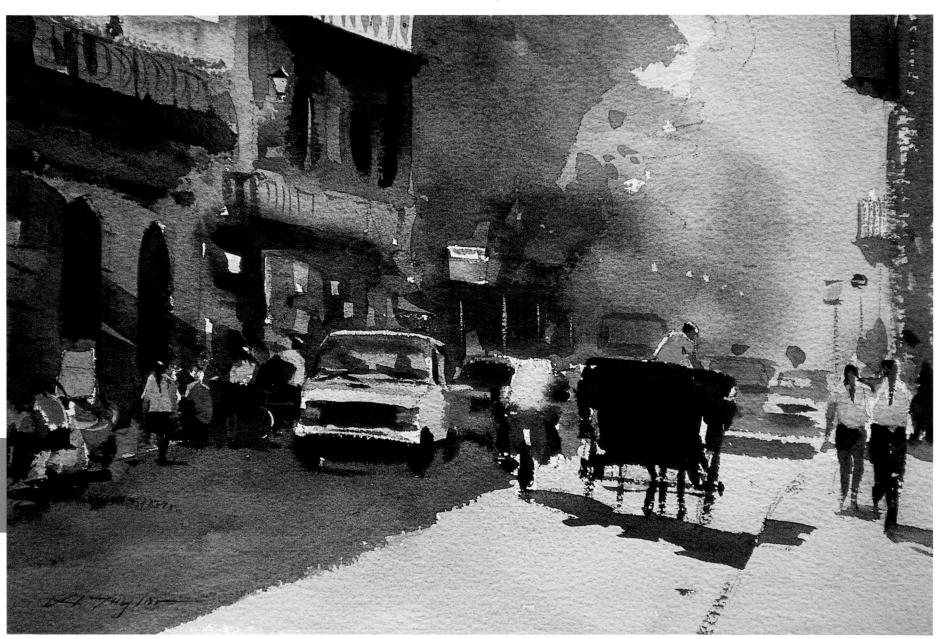

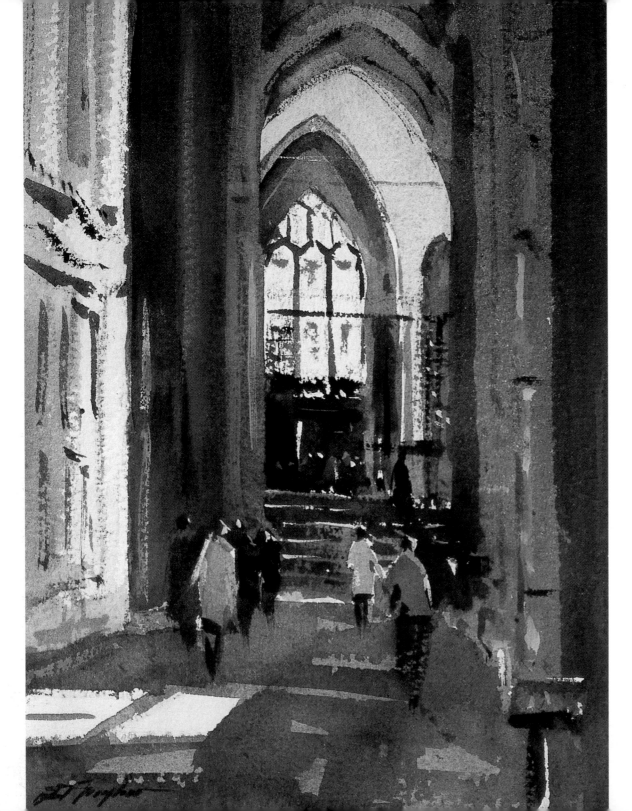

Winchester Cathedral, 11 x 7½" (28 x 19cm)

When tackling this sort of interior one of the most difficult problems is balancing the various dark tonal areas, while also handling the light from the large windows. David used the white paper for the window. Notice the way the light areas on the bottom left balance the light curved area around the window. Figures are very important in this scene, because they provide scale for judging the size of the interior. Without figures, this could look like the interior of a parish church. Figures also provide more color than an otherwise restricted palette. Notice too, how the intricate details of the cathedral have been merely suggested.

Ebb Tide, St. Aubins, Jersey, 11 x 15" (28 x 38cm)

There are many lessons to be learned from this painting. First, notice the horizon, which is painted a very cool blue, but with a touch of pink to hint at the distant houses. Also, merely hinted at are the yachts at their moorings. The harbor wall is the most dominant part of the painting because of the dark tone used.
The stored boats are freely indicated, mostly with dark, negative shapes. The warm dark wall is even further darkened at the base to enhance the three boats in front by counterchange. These boats are in turn indicated by the minimum of quick, spontaneous strokes, as are the ones on the left. The foreground harbor floor is brought forward by the warm fresh wash. A few quick flicks are enough to indicate the harbor debris.

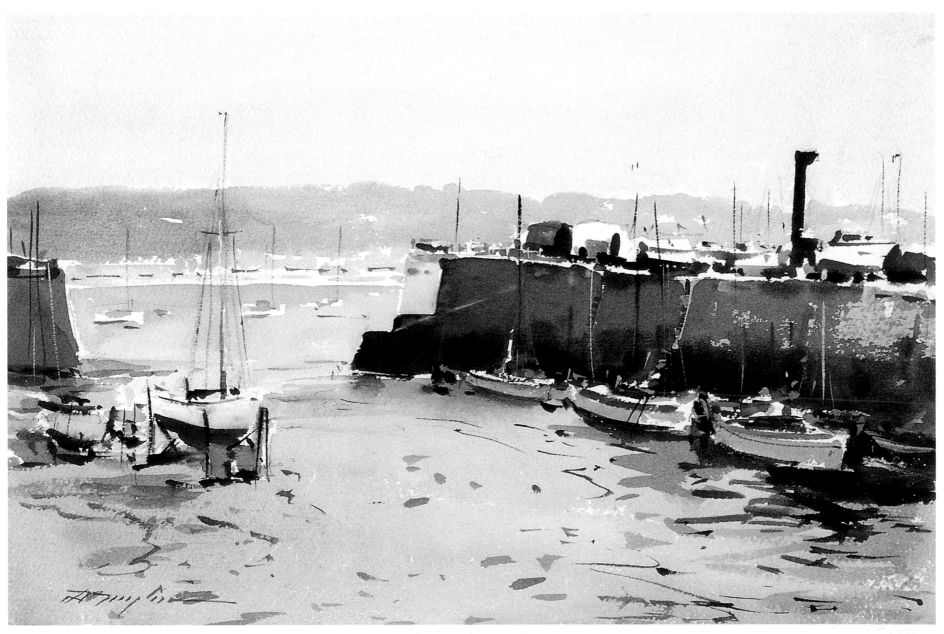

Creating lost and found edges

The lost and found technique forms a very important part in David Taylor's painting philosophy. He endeavors to achieve it through brushwork.

But what does this phrase "lost and found edges" mean? In David's own words they are, "Images that appear quite sharply, and then dissolve into mystery and soft tones, even vague shapes, creating a sense of distance, recession, and flowing atmosphere". It is a fascinating and subtle way of teasing and pleasuring the eye and imagination of the viewer. It also, importantly, avoids the cardboard cut-out look in your watercolors. So, how do you learn this technique? It requires discipline and a lot of practice. When applied convincingly, lost and found edges can take your work into another league.

Laneway, Murrurundi, Australia, 11 x 15" (28 x 38cm)

This is an excellent example of a painting with lost and found edges occurring throughout. The subject could have easily been painted in a flat, boring way, but David has given the subject an intriguing touch of mystery, in which the viewer is personally involved. One example is how the houses on the far left appear sharp, and then soften.

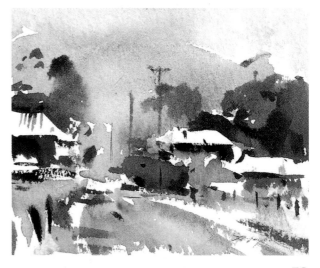

Understanding the process of lost and found edges

Breezy Moments, Yarra Glen, 10 x 14" (25 x 36cm)

This is a painting of enormous vitality, an excellent example of the effect of lost and found edges in any composition. Take the two gum trees; their hard edges are softened in part. The one on the left has wet-into-wet areas, while the one on the right has been treated with the dry brush technique. Notice the area of green and dark blue in the foreground. The hard edge at the bottom blends into the green, which in turn blends into the hillside. The areas of untouched white paper provide us with the contrast of hard edges throughout the painting.

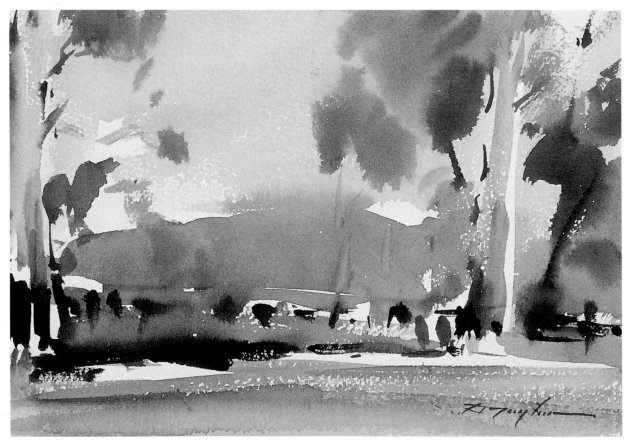

If you haven't consciously used this technique before, where do you begin? No matter how many words I write about it, the only way to explain this technique is to use the text in conjunction with David's paintings. I'm afraid that this means more work and concentration from you, but I promise it will be worthwhile. Read the captions carefully, noting each reference in the actual painting. I feel sure that by the end of the chapter you'll have a much better idea of how the technique can be applied to your own painting.

One of the wonderful things about impressionistic areas in David's paintings is the way in which they stimulate the viewer's imagination and creativity. The use of lost and found edges produces vitality and atmosphere in a painting which could otherwise be static and flat.

In most instances, strong, sharp lines can be softened into lost edges blending into the background, and this is perhaps the most obvious way of achieving the effect. However, a lost edge can also be obtained in a completely different way, by using the dry brush technique. As the brush is pulled lightly across a textured surface, the color becomes broken and fragmented — in fact, a lost edge.

The Heart of the Hunter Valley, 21 x 31" (53 x 79cm)

This painting has an entirely different mood. There's a tremendous sense of space and distance, much of it achieved by the change of color temperature, from the cool distance to the warmth of the foreground trees. The examples here of lost and found are most easily seen in the foreground trees and houses. Look closely at the edges of the trees, at how they appear and disappear.

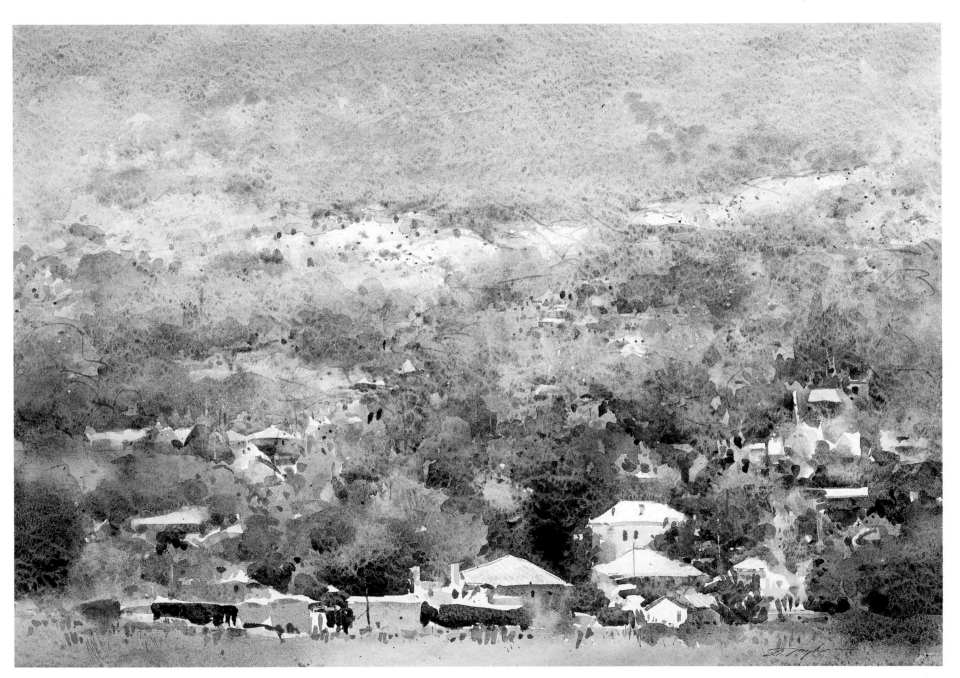

Lost and found edges in a busy market scene

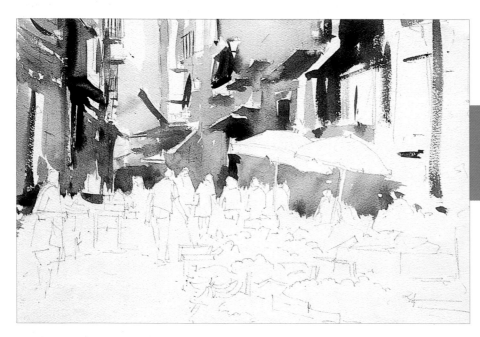

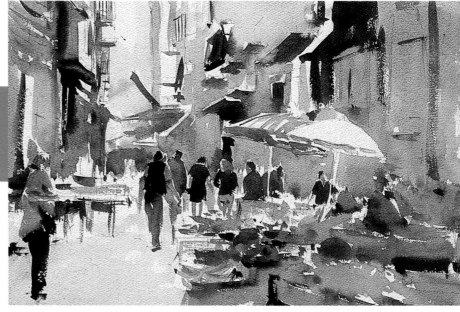

This busy market scene in the Italian city of Palermo provided David with an irresistible subject. There were so many plus factors. It was seething with bustle and activity, and the cool shadows of the narrow street showed up the rich, colorful foreground produce to perfection. The umbrellas were very important, providing a light area against the dark tones of the buildings. It was also an ideal opportunity to demonstrate the effectiveness of lost and found edges. Throughout the picture the eye can lose itself in soft wet-into-wet areas, while in others sharp edges dominate. In this painting David used eight colors — Raw Umber, Cadmium Orange, French Ultramarine, Cadmium Red, Cadmium Yellow, Burnt Sienna, Hookers Green and Sepia.

Laying in the background

After the initial drawing, broad background shapes help to set and establish a great deal of surrounding interest, which is so important in these early stages of a painting. The umbrellas on the right needed to be identified early in the work, as did the outline of the figures. You will notice that this stage is painted using fairly cool colors.

The foreground comes to life

The first cool colors are enhanced with advancing warm colors, still leaving lots of white paper to add to the freshness. Notice how some edges drift into others, linking the painting together. The figures are now indicated with strong, rich color. The lost and found edges of the vegetables are placed in the foreground.

The completed painting

In this final stage you will notice how all the darks have been added, giving necessary depth to the work. All the tones, from the white of the paper to the darkest dark, make it satisfyingly complete.

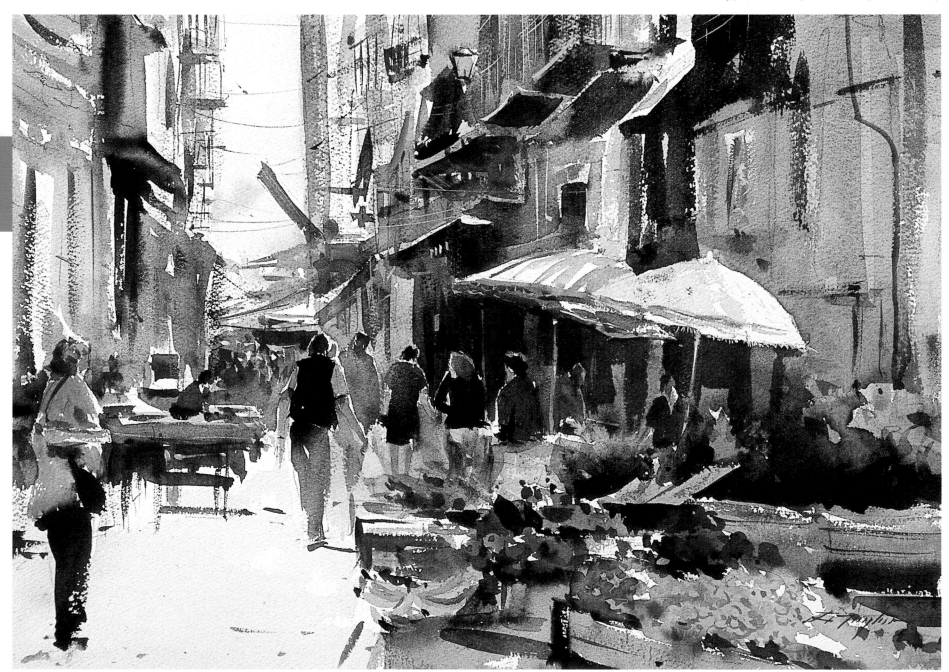

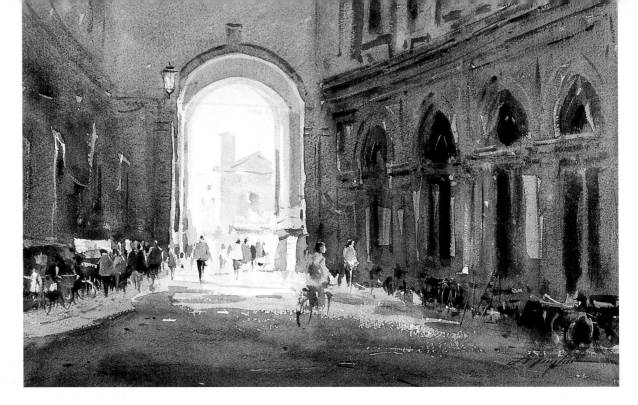

Many of the paintings in this chapter are of open country and woodland scenery and, of course, the lost and found technique lends itself very well to this type of subject. However, it works equally as well in the portrayal of buildings in towns and cities. In fact, once mastered, it can be used for any subject, from landscape to portraiture, seascape to still-life. Take the paintings on this page for instance. The eye is constantly teased by the mystery of "now you see it, now you don't".

Inside looking out, Padua, 15 x 22" (38 x 56cm)

Here we're looking into the dazzling light of a sunny day from the deep shadows of a huge arcade. One very interesting point here, is that the head of the lady on the bicycle is shown hard and sharp, contrasting against the dark building, while the bicycle gradually disappears into softness. The same thing happens at each side of the picture to the objects in the foreground, which soften off into the shadows of the buildings. The shadow across the foreground area is interesting, too. It contains wet-into-wet, and dry brush, lost and found, as well as many colors to entertain the eye. Look also at the high key painting of the buildings outside, and the economy of stroke used to suggest them.

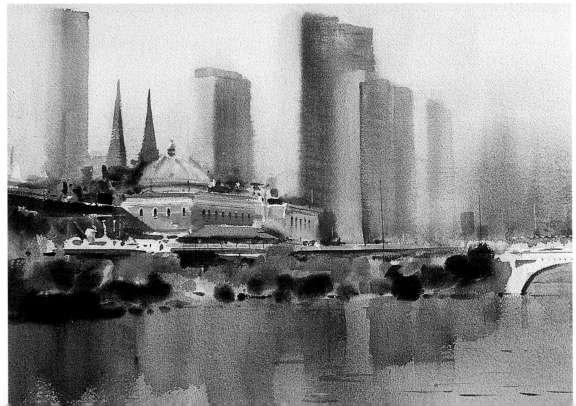

Lost and found in town and country

Autumn on the Yarra, 8 x 10" (20 x 25cm)

This is a painting of the center of Melbourne, it shows very clearly how large city buildings can be lost and found, just as easily as foliage. Parts of this picture are done with hard edges, while others are lost completely. This contrast keeps the viewers constantly on their toes. The painting has obviously begun on very wet paper, and David has then brought parts of the composition into focus as the paper dried. The trees on the water's edge have been put in with rich dry paint on a damp surface, while the reflections in the water are still in part wet-into-wet, again using the lost and found technique.

Windswept Landscape, Yarra Glen, 8 x 15" (20 x 38cm)

In this fresh, direct painting of the area around his home, David has used both techniques for lost and found, wet-into-wet and dry brush. Look at the various trees and you'll see that some of the crisp, hard edges at the top stand out against the sky, while other edges softly blend into the background hills. Notice how David has used the untouched paper to add a note of excitement. The touches of hard calligraphy, too, have their part to play.

Soft and hard textures in Paris

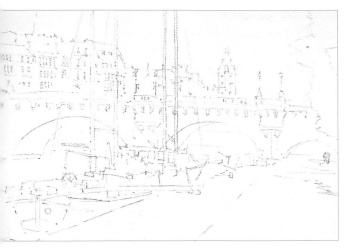

What mainly attracted David to this Parisian scene was the soft, misty mass of the Pont Neuf in the distance against the crisp, strong colors of the barge in the foreground. The other attraction was that this part of Paris was fairly quiet, so he was able to work without disturbance. You'll notice how the embankment provides an area of peace for the eye to rest in an otherwise busy painting.

The preparatory drawing phase

This is the initial pencil drawing, and it is worth studying. The drawing is done without too much detail. The lines are produced cleanly, not allowing the pencil to smudge the paper, which might sully the washes later. The barge is a complicated subject, but only the main features are put in, leaving plenty of room for spontaneous brushwork later.

Wet paper, dry paper

The paper is wetted with a large mop brush, leaving the area of the barge as dry paper. This is to preserve the whites so that contrast added later will be even greater. The background bridge and building are then painted wet-into-wet, consciously alternating between warm and cool colors in the washes to give variety and interest.

Handling visual competition

Now some details have been added to the background and more darks have been added, but care must be taken so the bridge does not compete visually with the barge. As the barge itself is painted, you'll notice how the preserved white paper counterchanges with the crisp dark washes to provide sparkle and spontaneity. The spots of pure color also give excitement.

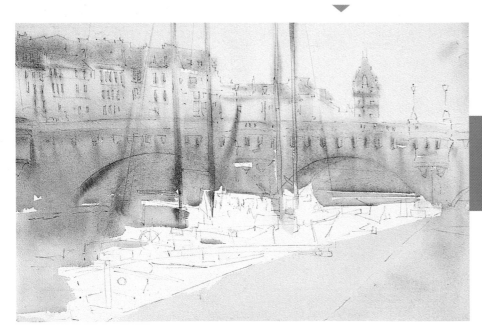

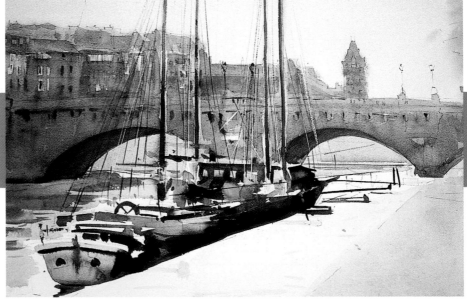

Adding details and balance

It is time to add the dark details. Notice how the tree on the right and the shadow balance the painting. The minimum of texture and dry brush are applied to make the embankment more convincing, and a few figures are added.

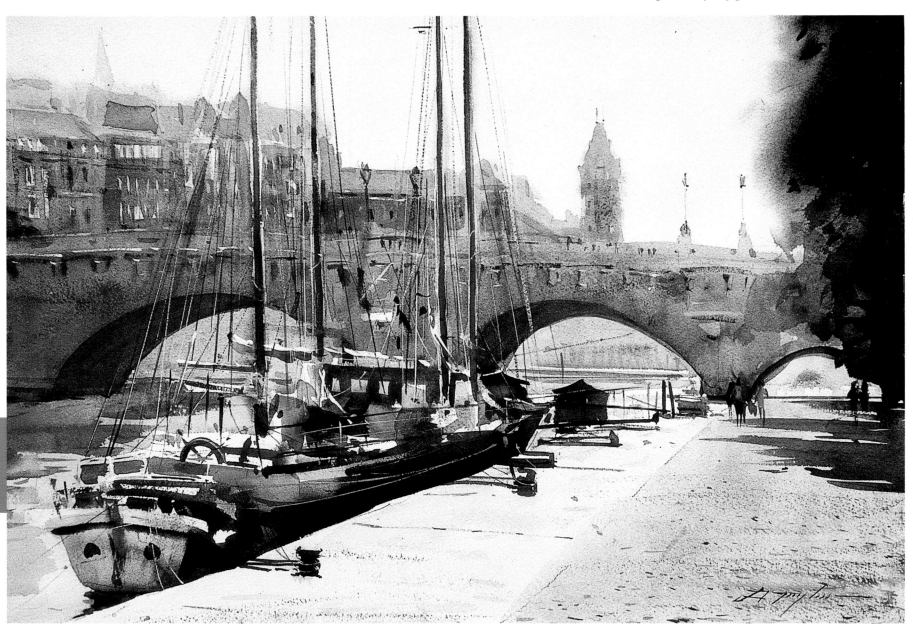

**Approaching Rain, Murrurundi,
11 x 15" (28 x 38cm)**

*The painting has got the lot. It thrills me to look at
it. Rich, warm and cool colors are used together with
wet-into-wet and dry brush to obtain the lost and
found edges. Just look hard at this picture for a few
minutes and discover for yourself where David created
lost and found his edges everywhere. The whites too
are important, adding real sparkle. The house roofs in
the foreground lose themselves in various places, while
some of the darkest darks have been put in crisply and
sharply on top of wet-into-wet. Don't you love the top
of the distant forest?*

Song of Autumn, Murrurundi, 15 x 22" (38 x 56cm)

*Lost and found edges are used throughout this painting. The lost
edges are predominant in the far background, giving the impression
of misty distance. As the painting moves forward, more hard or found
edges are used amongst the lost. You'll see this particularly in the
three large trees, with their hard edges enhancing the white buildings.
As your eye moves to the top of the trees you'll see that the edges are
more lost.*

Dam at Tarentaal, 14 x 21" (36 x 53cm)

*This dam is on David's own land, and here he has used his hard and
soft edge technique to great effect. The lost edges are mostly seen on the
left of the picture, and as the scene comes forward, more hard edged
whites are shown. The edge of the dam is mostly lost, but there are a
few touches of sharper brush strokes which prevent boredom. Moving
to the dark trees on the right, look at their profiles against the sky,
and see how they appear and disappear in an intriguing way.*

Lost and found in wooded landscapes

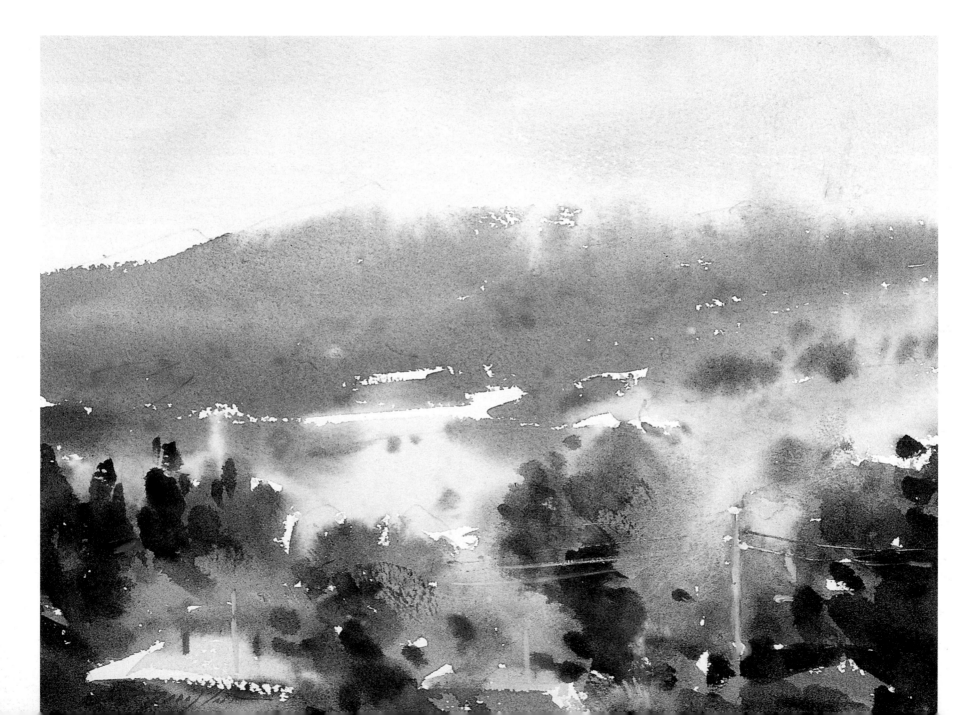

Working on very wet paper in Cornwall

The first wet-into-wet stage

David begins by saturating Arches rough paper on both sides and quickly painting the initial washes with strong color, indicating the main background shapes.

Merging blocks of color

As the paper is drying, strong shapes are blocked in with a flat sable brush. The colours and shapes are allowed to blend, creating lost and found edges, while some of the first washes remain untouched, retaining freshness.

David discovered the lovely town of Looe, on the south coast of Cornwall, while touring the West Country. The harbor there provided him with great subjects, and in this instance he found the fishing boats tied up against the quay irresistible. Having sketched the whole scene on a separate pad to establish the general composition, only then was he ready to begin his finished painting. As I said before, the preparatory sketch is important because it concentrates the mind and helps decide the positioning of the focal point, and the balance of the painting. In this case David decided that the two foreground boats were to be of primary importance, and so he positioned them at a spot which left a different distance from each edge of his paper.

Pulling the painting together

Once the paper is dry, the main boats are more fully indicated, and the rest of the darks added. Then come the reflections, parts of these carried out in dry brush.

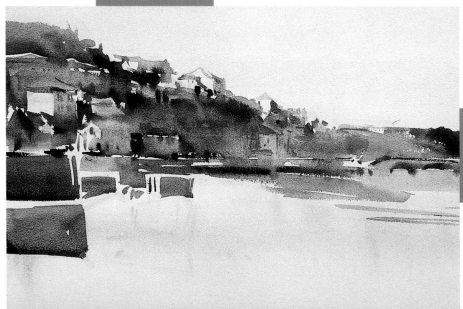

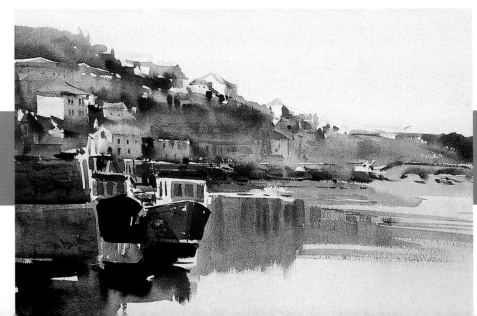

Marking Time, Looe, 11 x 15" (28 x 38cm)

In the final stage the ropes and mast are added with delicacy and speed. Notice how the strong red has been repeated — repetition is always a unifying factor. The softness of the original washes is enhanced by the sharper details.

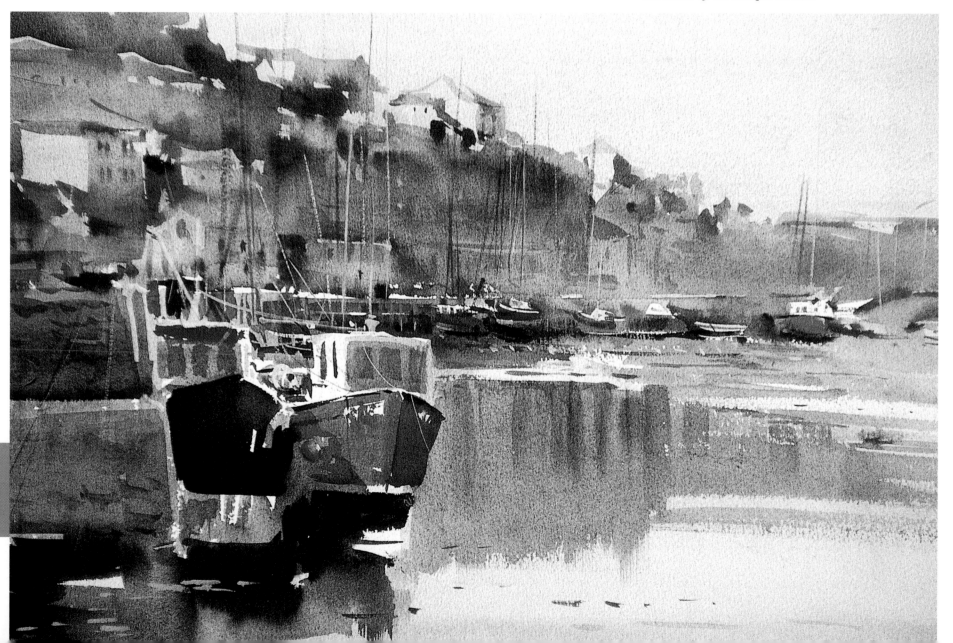

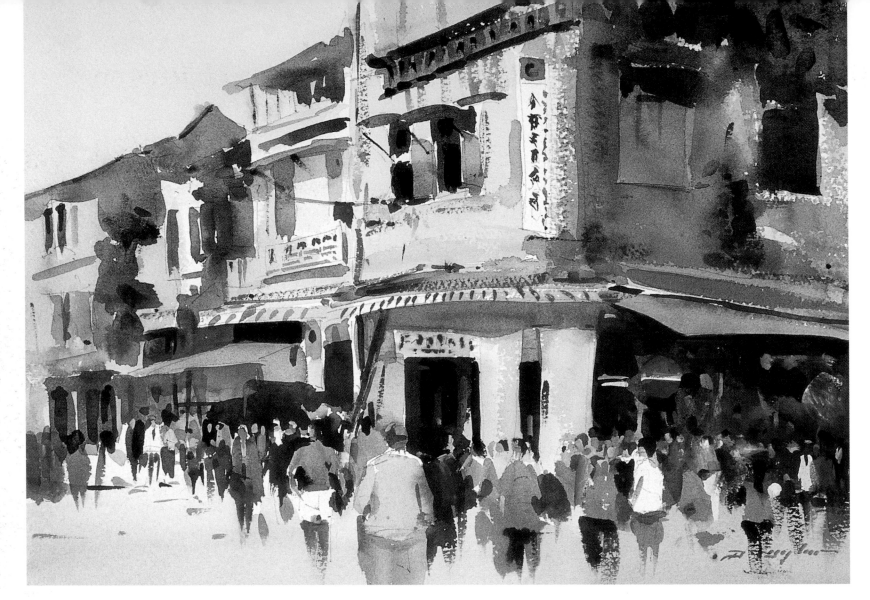

Old China Town, 11 x 15" (28 x 38cm)

The crowds of receding figures in this painting seem to draw you into the picture with them. Many of the legs become lost edges, while the torsos are sharp and crisp. This is a clear example of how David applies his technique to figures.

However, there are other parts of the painting in which objects have been intriguingly lost and found — look at the building in the right corner for example, and again to the far left, under the pink awning.

A High Street in Jersey, 11 x 15" (28 x 28cm)

This is an intriguing painting, where the sharp, crisp edges of the street itself, with its strong contrast, softens and blurs as the gaze travels up the picture. Slowly, trees sharpen at their trunks and gently blend at their crowns into the walls of the houses. Rising still further, the wet-into-wet wooded hillside is full of mystery and by adding the out-of-focus cream houses against the dark woods our eyes are teased and entertained.

Getting lost and found in Chinatown and Jersey

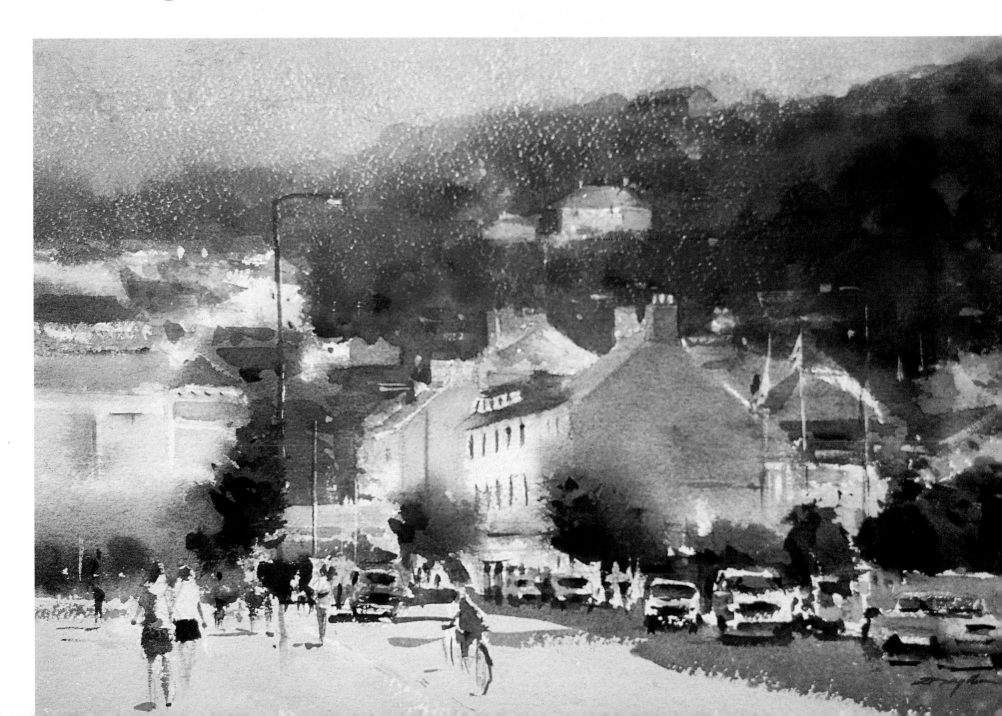

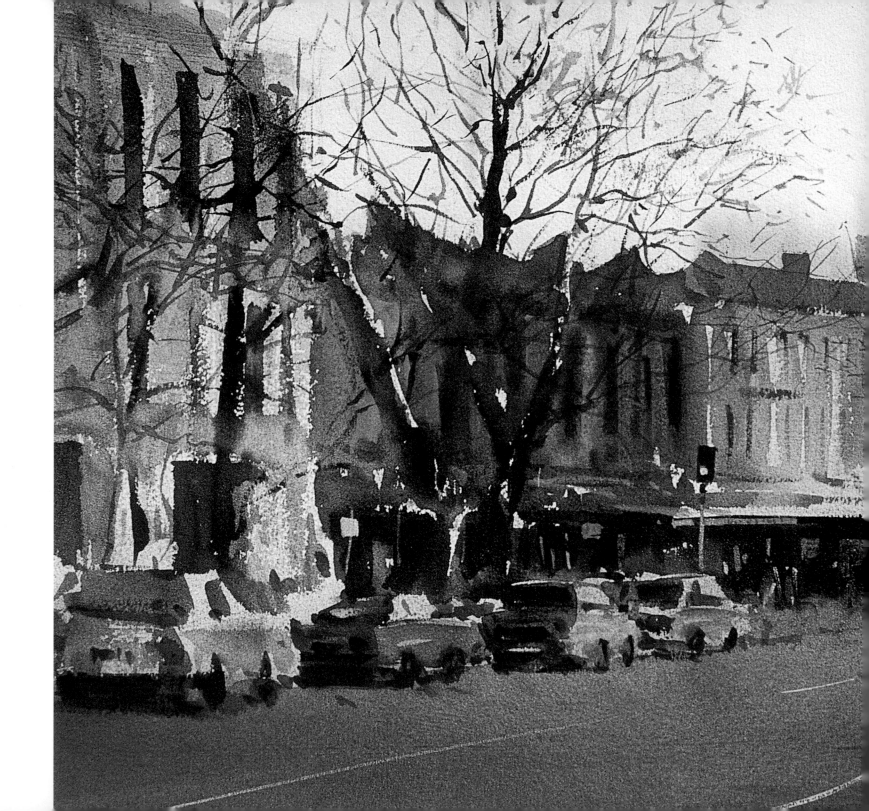

All the different greens in action

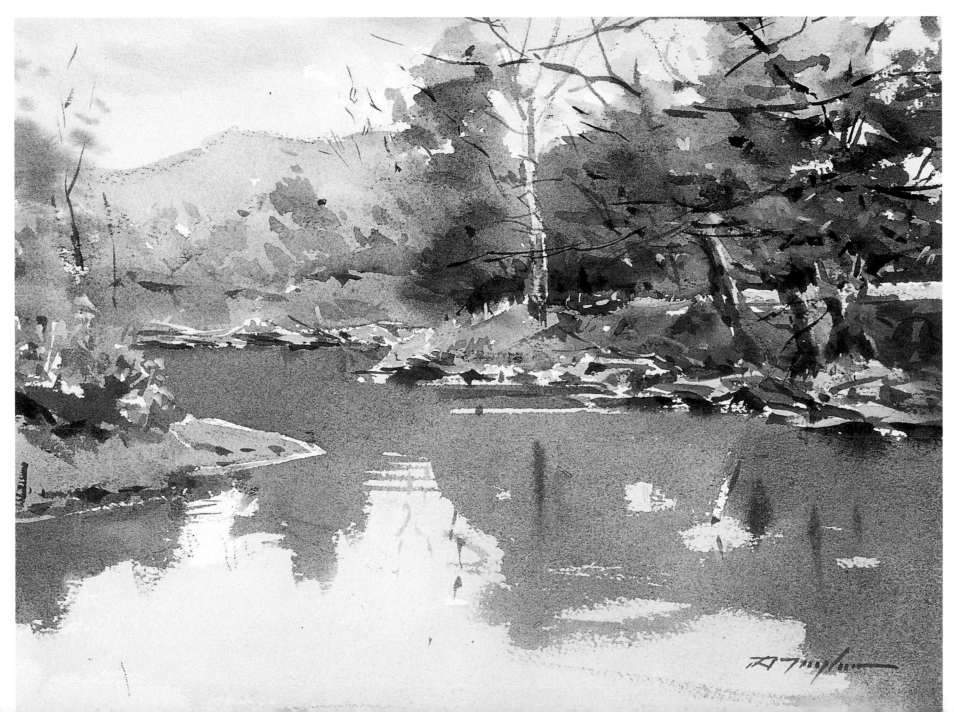

Colorful shadows in a street scene

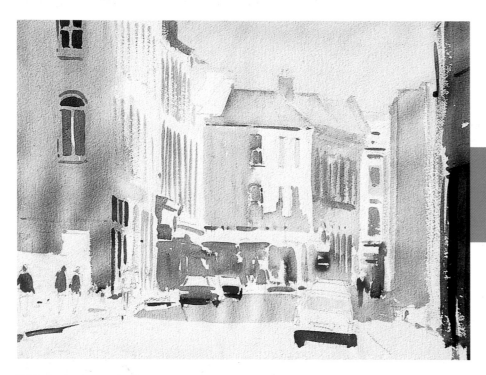

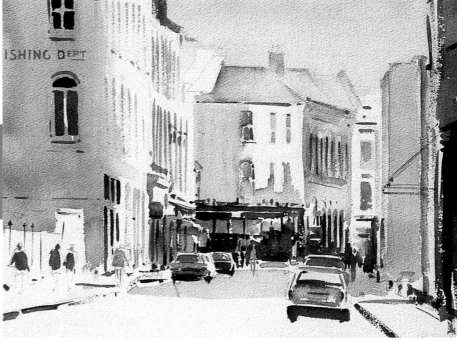

This is the sort of subject David thrives on, busy streets filled with people, cars and exciting shadows. From time to time he has exhibitions of his work at galleries in the Channel Islands and takes the opportunity to paint scenes around the various islands. This street scene is in St. Helier, Jersey. By working quickly, he finished the painting in one sitting while the light was constant. On the dry paper he made a simple, straightforward drawing stating the obvious buildings, boundaries and broad details only — too much unnecessary drawing inhibits a fresh result. Then he wetted both sides of the paper and began painting. Even in a complex street scene like this many ingredients can be merged into larger basic shapes to give overall simplicity.

The painting is first blocked in with broad shapes, which are essential to hold the picture together in the beginning and avoid any suggestion of "bitty-ness". After the background washes are on come the windows, which are touched in freely. Some of them should have broken edges, which is done by using a fairly dry brush and a quick stroke.

With the main shapes established, the stronger tones and details are put in. However, the word detail is fraught with danger. Details should be put in with speed and courage, avoiding tightness. Make sure that some of the colors mix on the paper, rather than your palette — look how much this has happened on the dark shop windows at the end of the street.

Now it's time for the figures and finishing the cars. Remember to keep the heads small and the bodies tall. Finally, the main overall shadows are added. (Work out beforehand exactly where these shadows should be, then take a deep breath and put them in quickly and decisively.) The shadows seem to pull the whole picture together. Compare the last two stages.

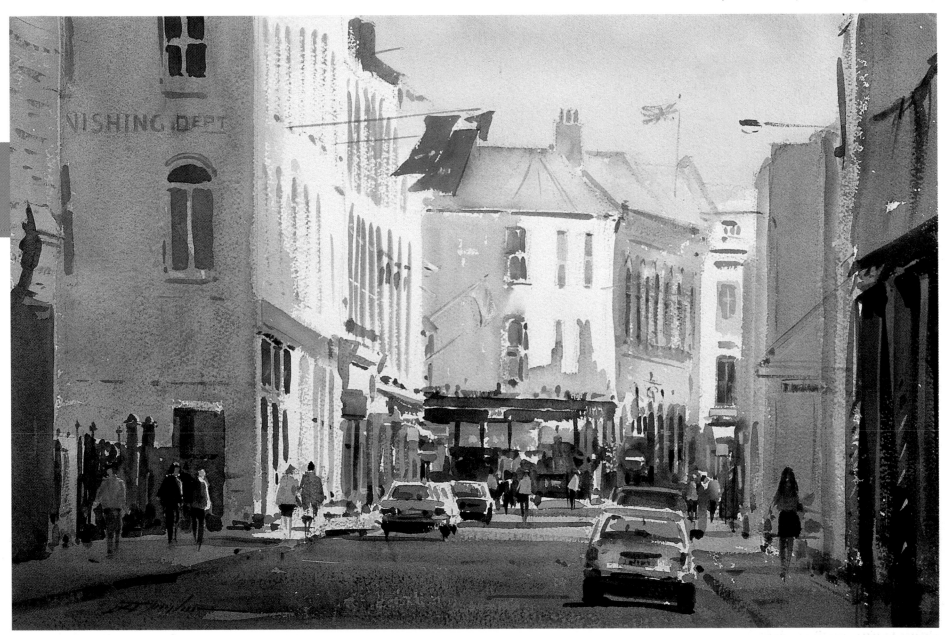

Rivoli Corner, St. Helier, 11 x 15" (28 x 38cm)

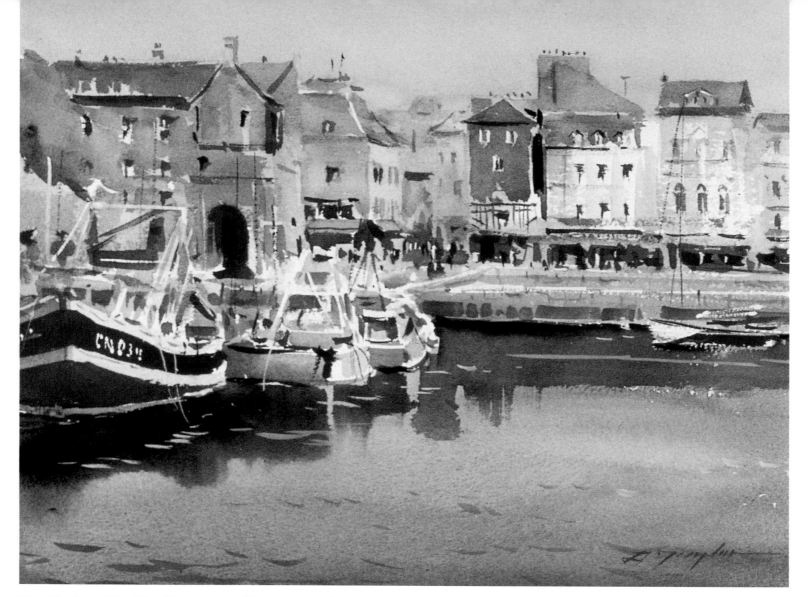

The Harborside, Honfleur, 11 x 15" (28 x 38cm)
This little fishing port in France is a magnet for artists everywhere. It is full of boats, cafes, throngs of holidaymakers and dancing color and David has made the most of it! The color of the water has really set the scene, and from it one imagines a cloudless blue sky. The rich shadows under the bright orange and blue awnings suggest sunshine. Areas of untouched paper give sparkle to the fishing boats, and there is still more color on the green tarpaulins. The dark reflections in the water accentuate the bright quayside.

Reaching for the Sky, Melbourne, 15 x 22" (38 x 56cm)
David's instinctively creative use of color has transformed what could have been an ordinary street scene. The liberal use of mauve on top of a warm under layer has given life to the road surface. Notice that the same mauve has been repeated behind the parked cars on the right, and on the shadow sides of the buildings. The rich wet-into-wet trees, also on the right, have been further enhanced by the bright red blossoms. The same red has been repeated in one of the cars, and one of the figures, to provide unity. Do look too, at the parked cars and the incredibly simple way of treating them.

Color magic on both sides of the world

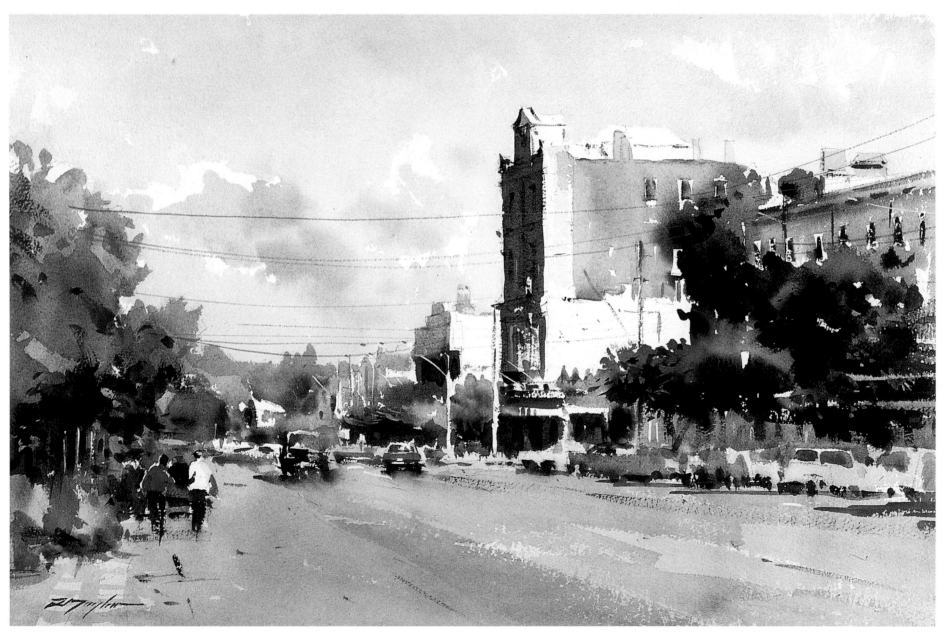

Enhancing your paintings with warm and cool colors

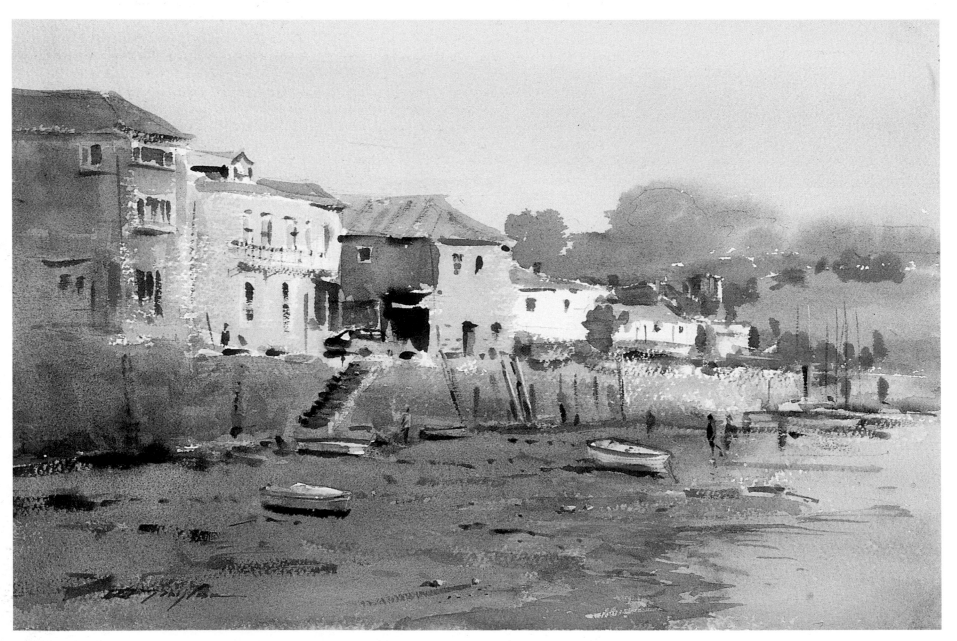

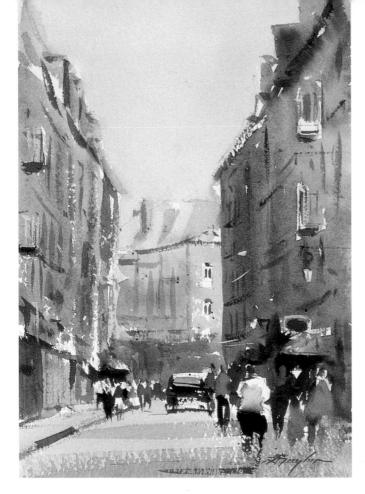

On the Move, St. Malo,
15 x 11" (38 x 28cm)

While this is seemingly a straightforward street scene, David's use of rich, contrasting colors at the bottom right has filled the picture with vitality. Cover this area up and you'll see how important it is. It is extremely unlikely that such a riot of color was there at the time, but this creative use of color and contrast is there for all of us to use if we have the courage. Note the playing down of the building at the end of the street to give a definite depth of distance. The warm shadows in the street, painted in the dry brush technique, are also important.

Darling Downs, Queensland,
11 x 15" (28 x 38cm)

This typically Australian scene is full of sharply contrasting tone and color. What takes this painting out of the ordinary is the deliberate exaggeration of the color range. The dark greens and yellows of the foreground begin to cool down in the middle distance, and the cool range of delicate mauves takes over. This is so vividly painted — and yet so much is left to the imagination, giving the viewer a host of possibilities. To keep unity in the painting the mauves have been repeated throughout, from the foreground building to the completely believable sky.

Low Tide Salcombe, 11 x 15" (28 x 38cm)

This is a great example of how David has enhanced his colors beyond what is actually in the scene. While still being true to the spirit of the scene, he has injected more in the way of visual pleasure. In reality, the foreground beach is basically warm ochre, but the distribution of the cool gray/green and blues brings out the warmth even more. You'll see a variation of this technique in the foreground buildings on the left. As the picture recedes into the distance David has deliberately cooled and simplified the greens of the background grass and trees to accentuate the depth. The dark, contrasted area of the top of the harbor steps has become the focal point.

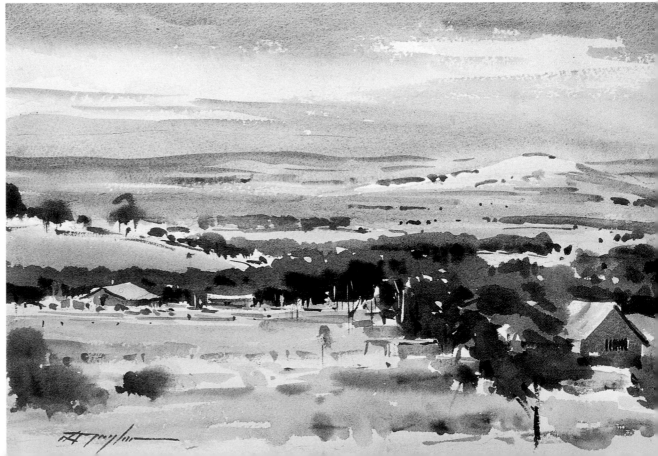

Tune in to colorful street scenes

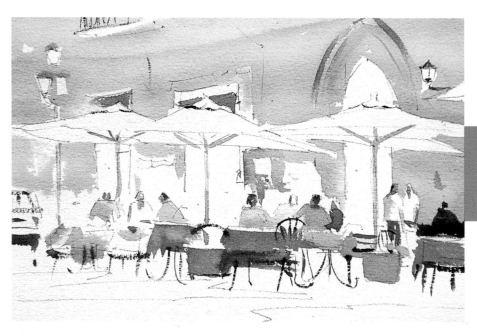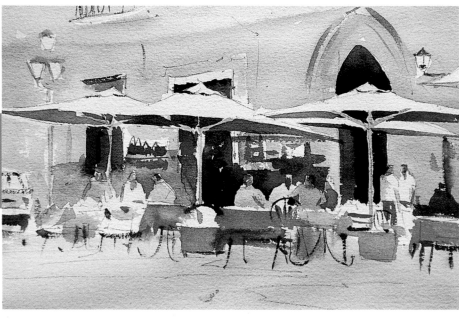

When wandering around the streets of any town or city, let color be your guide. Tune in visually to the colors that surround you. Select an area and try to see it as a finished painting filled with rich color and light. For example, take this scene; David was walking in the streets of Cefalu, in Sicily where he was teaching. It was a warm day and there was a holiday atmosphere. His eye was caught by the red tablecloths and colorful shirts, made dramatic by the strong shadows. An added advantage was that he clearly had models who were content to stay there for some time enjoying their coffee and the friendly company.

After completing a simple drawing, many of the lighter tones of the background are added, making sure that there is plenty of variety of color in the stonework, and leaving untouched paper for the umbrellas. The tablecloths are painted in a mixture of Cadmium Red and Raw Sienna. Cadmium Orange is also used to provide warm color in surrounding areas. The figures are also indicated during this stage.

Colors used

Aureolin, Raw Sienna, Cadmium Red, Cadmium Orange, Brown Madder, French Ultramarine, Cobalt Blue and Sepia.

Strong shadows in the doorways and under the umbrellas give power to the design, and the table legs and chairs are swiftly indicated with the rigger.

Now the rest of the shadows are added, which bring the picture to life by emphasizing all the light colors. Shadows must always be fresh, spontaneous and colorful, but never overworked.

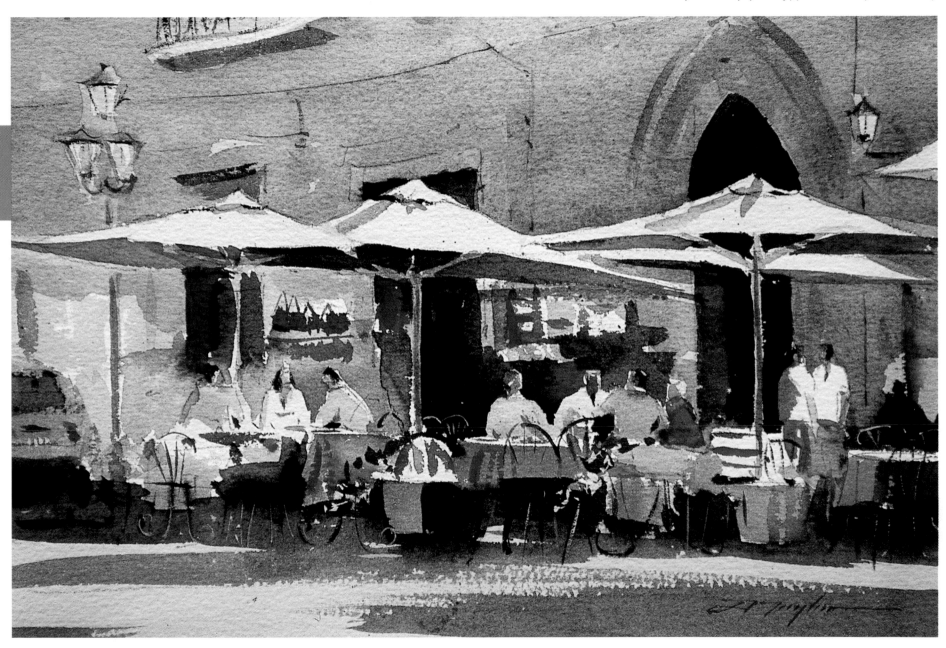

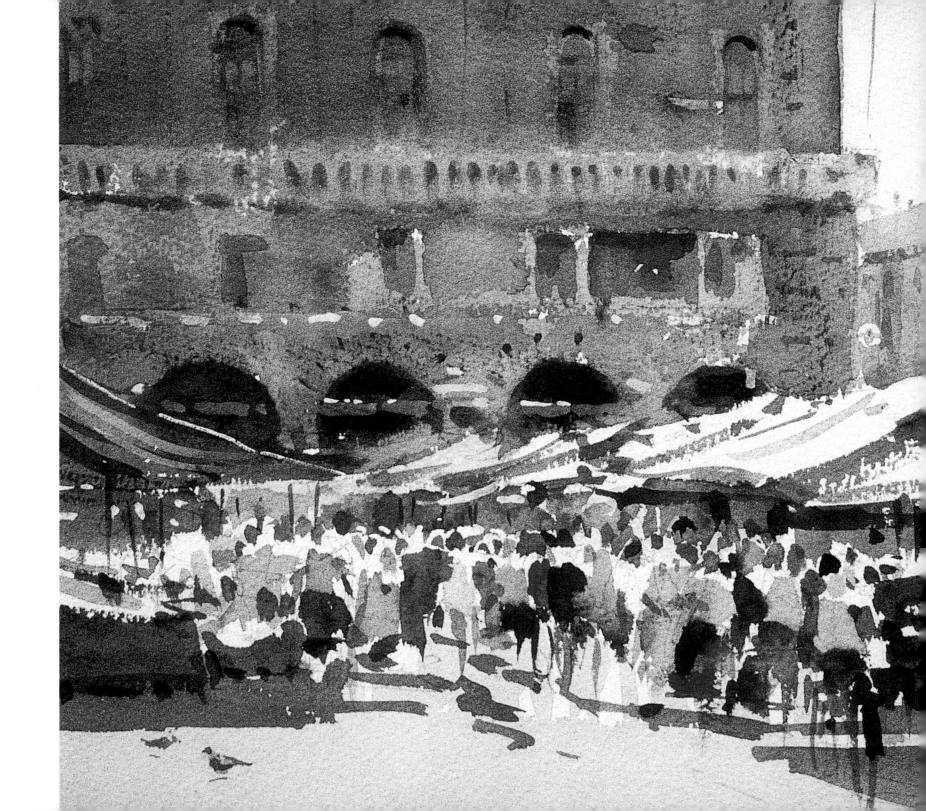

Spontaneity and movement

These two words, spontaneity and movement, are interlocked in painting. One promotes the other. But how do we capture this elusive quality. Without it our paintings seem pedestrian and predictable, lacking excitement no matter how much color is put into them. One thing is for certain — you can't fake spontaneity. There is no easy way out. "What if I just painted faster?", you may say. Sorry, but it is not as easy as that. Your paintings would then just look careless. No, I'm afraid you are in for a long, hard ride — spontaneity can be time consuming! Real spontaneity can only be achieved by consistently handling the brush with confidence, deliberation and conviction. Yes, speed of application is important, but it has to be speed combined with hard earned skill. That skill only comes when you have thoroughly mastered your materials through years of constant practice.

Padua Market, 11 x 15" (28 x 38cm)

This a painting full of contrast — the contrast of the large background buildings against the white awnings of the market, and the contrast of the cool muted colors of the same buildings against the hot, vivid hues of the produce in the right foreground. Overall however, the whole painting is full of spontaneity and movement because of the way the crowds are handled, with the figures merging and constantly overlapping.

A rough color pattern of the scene.

Shown on these two pages are four examples of David's work painted in a particularly spontaneous style. Studying them as a group may help you to analyze his free approach. As your eye goes from one to another, you can see his shorthand method of suggesting such things as windows, roofs, walls and figures.

When you are painting in this style, with quick brush movements, a window or a door may appear out of line, or a curve misplaced, and the temptation is to stop and correct it with another stroke — don't. Wait until the completion of the painting and then decide if anything needs attention. It probably won't — the eye will quite happily take in the impression as a whole, whereas corrections will stand out like a sore thumb.

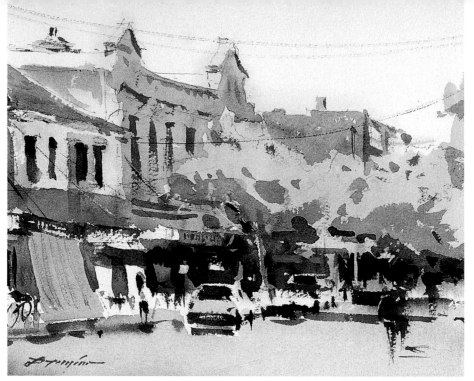

Summer Gold, Bay Street, Brighton, 8 x 10" (20 x 25cm)
This very simple pattern of colors and tones gives a wonderful impression of gaiety and vitality. Particularly effective are the strong darks against the vibrant yellow of the trees. The cars are again indicated with great economy, and yet they are totally believable.

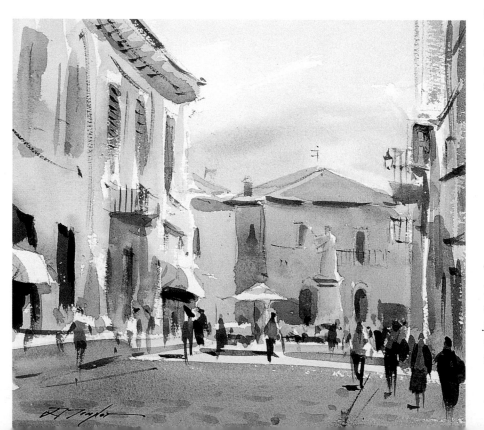

Town Square, Norcia, Umbria, 10 x 12" (25 x 31cm)
The simplicity of treatment here is so deceptive — it looks as though anyone could do it. However, a painting like this demands enormous restraint and discipline from the artist. Take the people for example, separately some of them might not work but, collectively, they're entirely convincing. Look at the importance of the tone, and color of the shadow across the street.

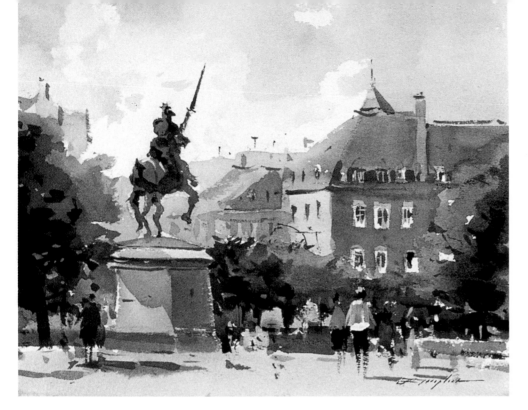

A Salute to Dinan, 8 x 10" (20 x 25cm)

The autumnal shades and warm tones of the buildings set the atmosphere of the sunlit square. While the statue has been put in with simplicity and directness. It's the bottom right corner that I find most exciting. Adjacent to the black and white figure are placed some lovely touches of red, blue and pink, which are entirely satisfying. The entire picture has been beautifully harmonized.

Life Along the Sea Wall, 10 x 14" (25 x 36cm)

What makes this picture so forceful, is the tremendous richness and variety in the green of the trees. This is further emphasized by the simple treatment of the sunlit beach. The sea wall is treated with simple competence, while the calligraphy of the railings and touches of red and blue complete the scene.

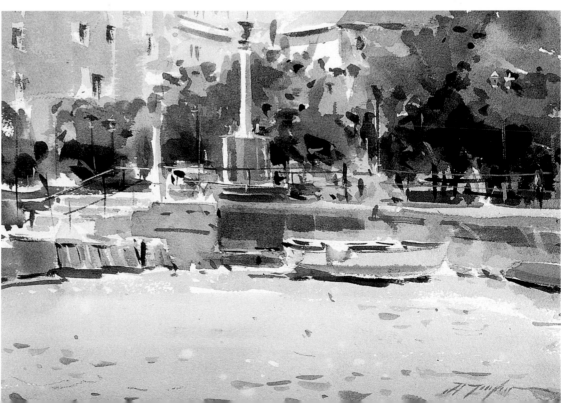

Portraying the bustle of an English

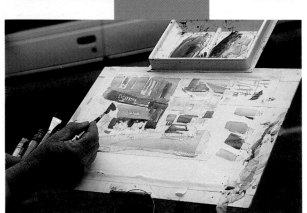

The drawing having been completed, light washes of warm color go in. Burnt Sienna, Brown Madder, Raw Sienna, together with complementary cool blues, go in wet-into-wet.

The painting is well under way, and the time has come for David to establish the main broad shapes, covering the surface as quickly as possible and leaving all details until later.

The awning and the activity need to be established. It is necessary to get the figures in very quickly, as they moved faster than his brush! You can see some lost and found edges, where David has allowed the green awning to bleed into the red in the darks behind the figures. Sepia, Burnt Umber and Cadmium Red are the colors used.

During David's last visit to the UK, the main purpose of which was to allow time for us to work together on this book, he also took the opportunity to tour various parts of England. In Somerset, he was delighted to discover Linton, and soon set up his easel in the main street of this charming town. He was attracted by the color and strength of the subject and felt that the passing shoppers and stationary vehicles added impact and excitement to the general atmosphere. This first instinct was right. I'm sure you will agree that the final result is full of rich color and movement.

Most of the paper is covered and David begins work on the right side, putting in the parked vehicles and surrounding tones.

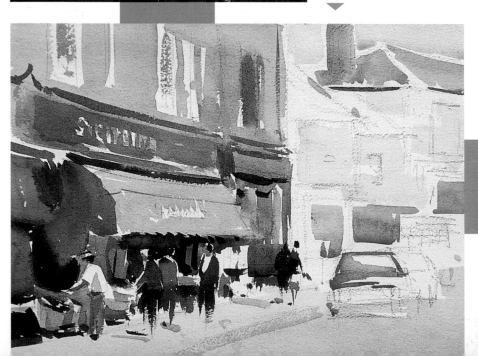

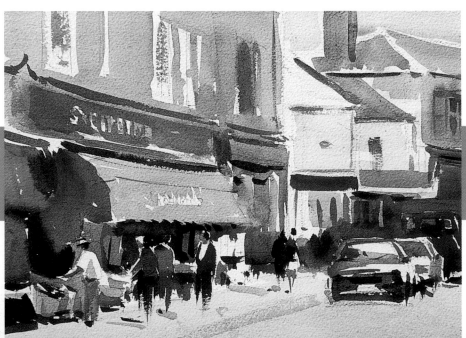

street scene

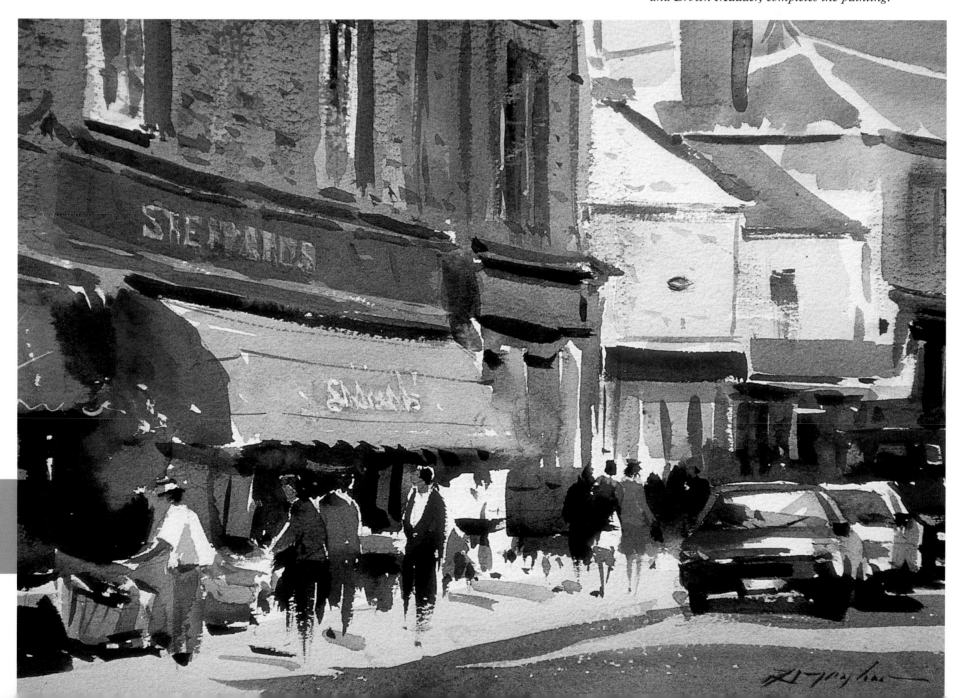

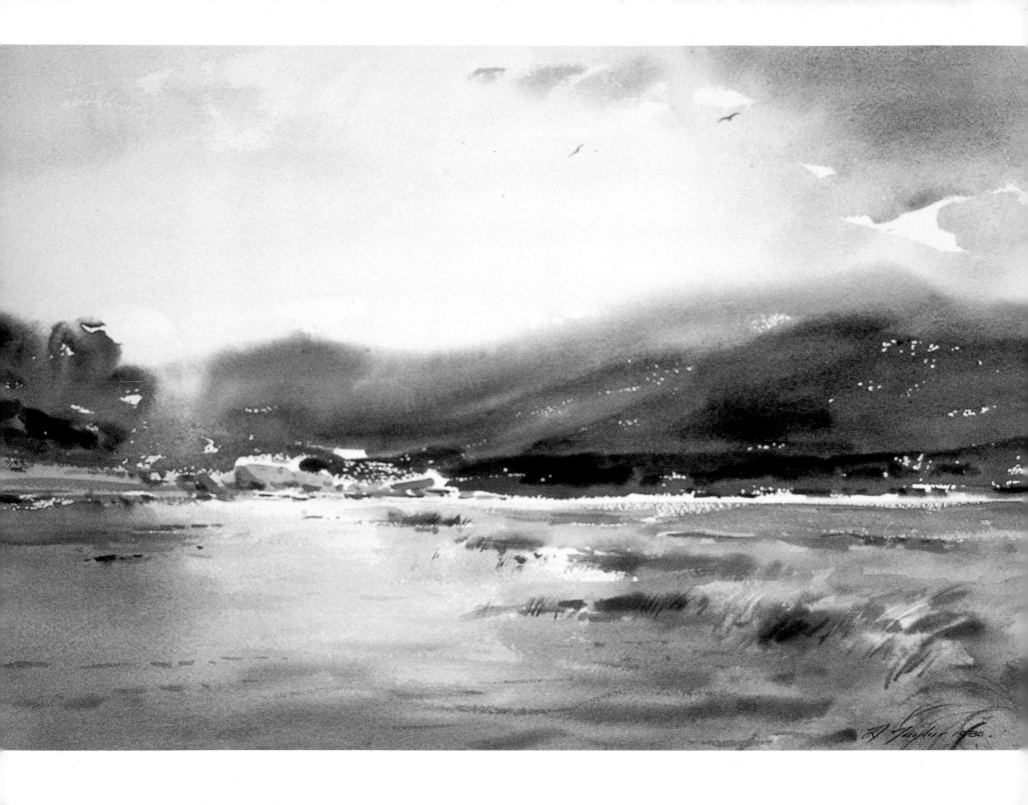

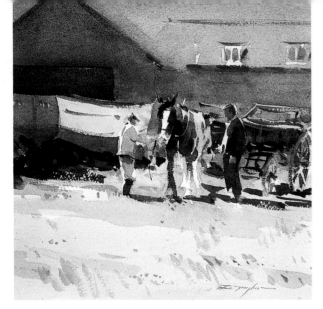

Getting Ready, Sark, 12 x 11" (31 x 28cm)

There are no cars allowed on the tiny island of Sark so horses are important. This painting describes the activity surrounding a draft horse as it is harnessed up and put between the shafts of a cart. The spontaneity lies in the figures and the horse, which are indicated with quick, light strokes that suggest movement.

Raining, Tidal River, Australia, 15 x 22" (38 x 56cm)

This is a wet-into-wet picture with the whole paper being thoroughly soaked before beginning painting. After the sky is finished the distant blue hills are put in with richer paint — the exact timing of this is always an educated guess, but experience plays a large part. The nearer, warmer brown hill is painted with ever richer paint as the paper dries. The river is tackled next, with the tree reflection put in first and the right foreground added in warm sienna of increasing strength.

Following the Shadows, Rome, 15 x 11" (38 x 28cm)

The most important thing about this painting is the great difference of color temperature between the distant city and the foreground buildings of this sunlit street. The delicate mauves of the background are high key, suggesting a misty morning, whereas the dark tree provides a sharp counterchange with the building on the left. David has introduced many other colors into this area, wet-into-wet, to provide visual entertainment, and the shadow colors added to the sunlit street are also varied. The entire painting is spontaneous, full of light, and punctuated by the dark but freshly indicated figures.

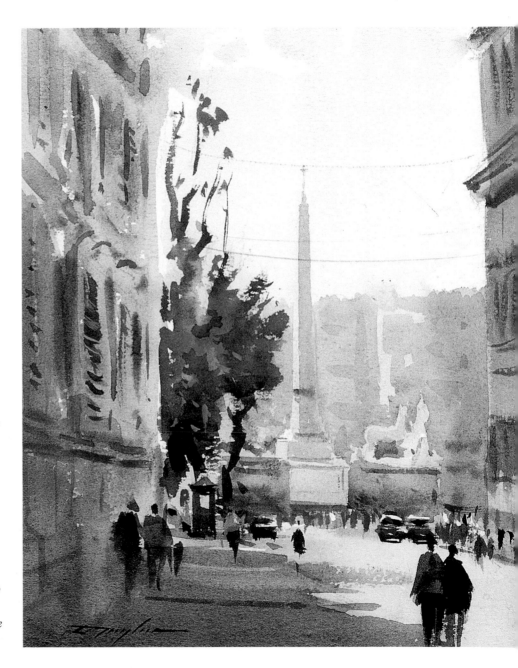

Spontaneous brushwork in the Channel Islands

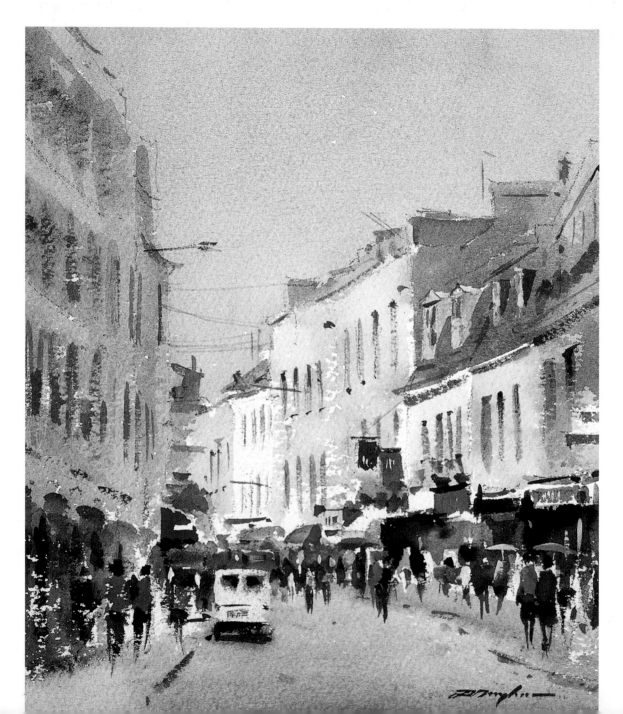

**Shopping in the Rain, Columberie,
11 x 7½" (28 x 19cm)**

The mood of this painting is dictated by the cool colors of the sky and the foreground street. The sky still looks rainy, and yet the sun is almost breaking through onto the light buildings in the middle distance. The lower one-third of the painting looks somber, with umbrellas, dark figures, and the cool tones of the street. The only relief is the white van, which becomes the main object of interest. The brushwork throughout is spontaneous and lively, yet David still manages to convey the atmosphere to match the title.

**Reflections at La Haule, Jersey,
11 x 15" (28 x 38cm)**

There's a wonderful lesson to be learned from David's use of white paper, especially when you notice how he has placed darks next to the whites to give maximum impact. This is a delicate composition, with beautifully transparent washes put in with fast, spontaneous movement of the whole arm, rather than working from the wrist. Spontaneity is everywhere throughout the painting, from the soft wet-into-wet background hills, to the subtle touches of strong, dark color exactly where it's needed. Many different techniques have been used here, but with an overall economy of stroke — you will notice wet-into-wet, dry brush, calligraphy with the rigger, even the inclusion of tiny dots, which in isolation would be meaningless, but as part of the whole create a sense of immediacy.

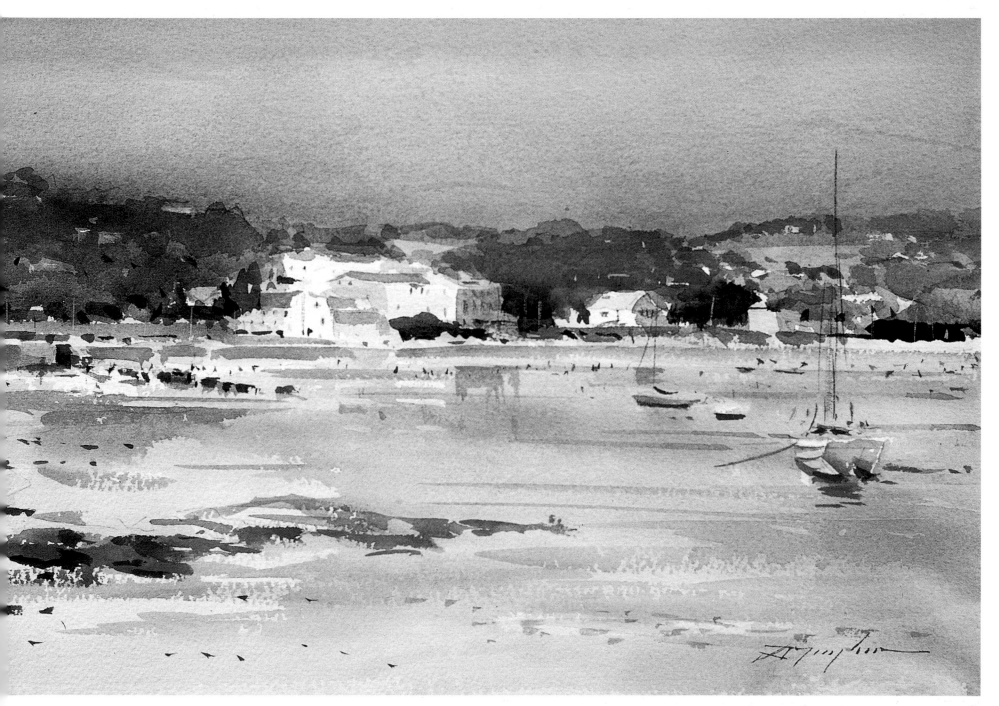

Arcade, Sorrento, Italy, 15 x 22" (38 x 56cm)

I freely admit that I really love this painting. It's full of vitality and spontaneity. The freshness appears deceptively simple and direct, masking the expertise on which it is based. But believe me, it's far more difficult to achieve this effect than to painstakingly draw every window and door. The use of untouched white paper is masterly, never obvious, but always strategically placed, scorning the use of masking fluid. The right foreground is worth studying carefully. So much is suggested with so few strokes. The awning, scarves, ties and all the other gift shop wares are merely hinted at, giving the viewer the opportunity to participate. Notice how this area is balanced by the rich, varied greens of the tree on the left. David has used counterchange, the dark cars against the light building, to enhance the brightness of the scene. This picture perfectly illustrates everything we've tried to say in this chapter.

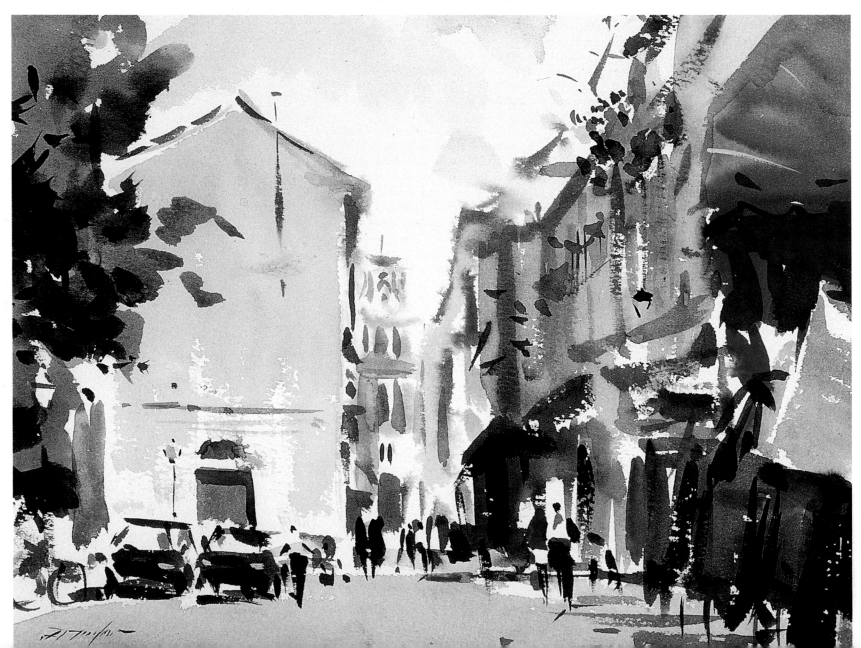

Mood and movement in a busy street

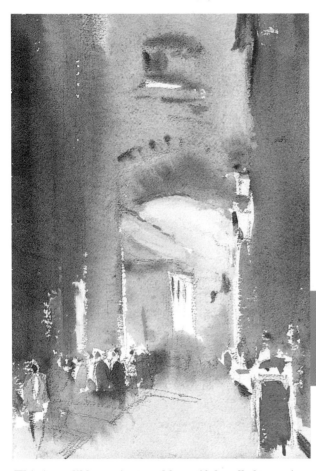

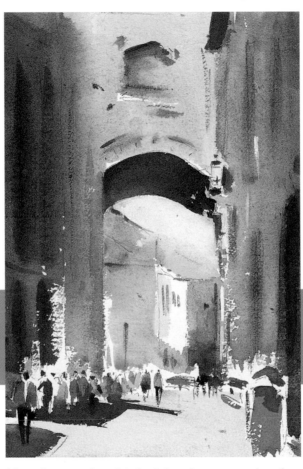

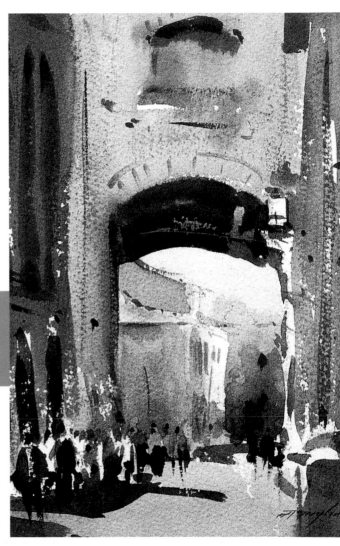

This incredibly ancient and beautiful walled town in Tuscany, famous for its towers, contains a wealth of subject matter for the artist. In this first stage the paper is thoroughly dampened and the main basic shapes put it with a big brush, David has used plenty of wet-into-wet technique, but is taking care to leave some whites for later use.

Now the paper has dried, giving the opportunity of putting in hard edged darks. David has made use of dry brush technique in various spots, and the figures are loosely indicated. The original white areas now have more meaning.

The Archway, San Gimignano, 15 x 11" (38 x 28cm)
In the finished painting you'll see that more color is added to the street surface and further definition given to the buildings.

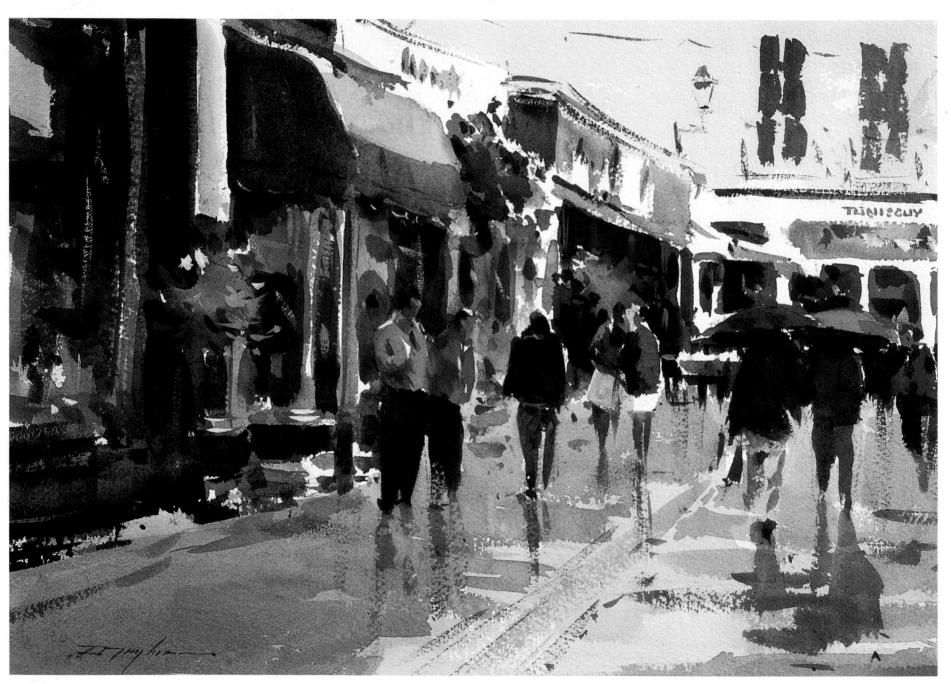

Reflections, Commercial Arcade,
11 x 15" (28 x 38cm)

This street scene in Guernsey absolutely typifies both spontaneity and movement in watercolor. It portrays action in the street, with the figures dodging the puddles — you can almost hear the splashes and raindrops. The economic reflections tell the story, as do the huddled shoulders of the figures. The goods in the various shops are merely hinted at with warm colors and plenty of darks. The understatement in the top right corner keeps the eye concentrated on the moving street below. Speed of application contributed to the success of this painting.

Narrow Street in Italy,
11 x 7" (28 x 18cm)

This exciting study done very quickly relies on enormous contrast to produce impact. It's a U-shaped composition with the dark, warm afternoon shadows making the light on the buildings at the end of the street look positively dazzling. The speed and confidence with which doors, windows and balconies have been hinted at give the feeling of spontaneity. Notice the way in which the three posts have been treated as negative spaces, with the shadow painted quickly around them.

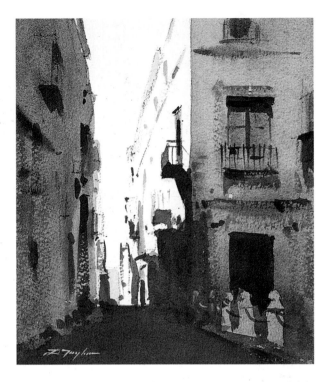

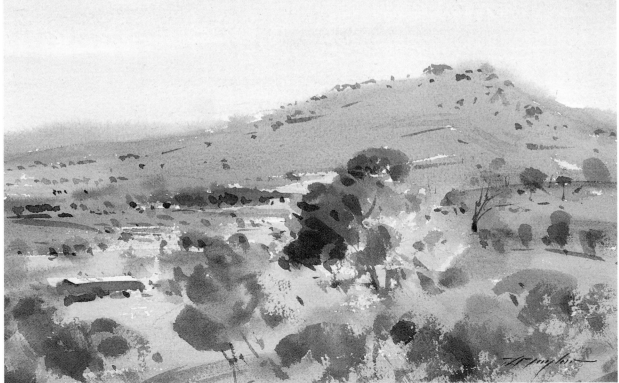

Fleeting Moment, New South Wales,
11 x 15" (28 x 38cm)

Although a complete contrast in subject matter from the other two paintings here, this again was painted quickly, on the spot. David was trying to get the feeling of the afternoon breeze by the angle of the brushstrokes moving from one side to the other, showing the actual direction in which the wind was blowing. Spontaneity therefore, is used to give excitement to an otherwise static landscape. Notice how the eye is attracted to the left middle distance where there is an area of maximum contrast.

Racing the weather!

When David came over to England to work on this book, he asked me to give him a list of my favorite painting spots — Porlock Weir was definitely number one. Within a few hundred yards there are dock gates, thatched cottages, boats of every type, all surrounded by hillsides, and with everything changing throughout the day as the tide ebbs and flows. Also, no one seems to bother you while you're painting. David has decided to concentrate on one elderly boat that has been left high and dry by the tide. His palette consists of Cobalt Blue, French Ultramarine, Burnt Sienna, Raw Sienna, Quinacridone Magenta, Aureolin, Sepia and Hookers Green.

Light washes for the lightest tones

The first light wash is laid in from the lightest tone on semi-damp paper. The sky is a mixture of two blues, with Quinacridone Magenta and Burnt Sienna used to gray the sky darks. The middle tones are then added. Notice how the leaning boat has been isolated to gain maximum interest and contrast.

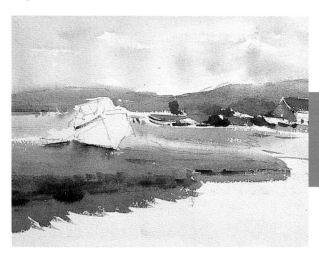

Focusing on subject

Now the general colors are added to the boat. The warm tones being Burnt Sienna and Aureolin, and the cool colors Cobalt, French Ultramarine and Quinacridone Magenta for the cabin. The boat now commands focus and the only things needed are final details and balance.

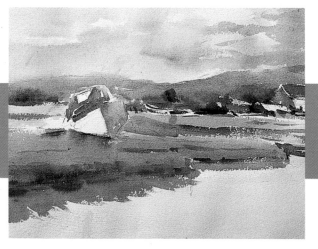

Adding important accents

The brush works quickly to deepen the reflections and sky, and to put in accents in the water on the right. The colors are intensified using Burnt Sienna and French Ultramarine for the accents.

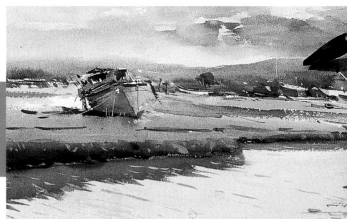

The Leaning Survivor, Porlock Weir, Somerset, 11 x 15" (28 x 38cm)
The finished painting is now dry and suggests the atmosphere of threatening rain while the boat lies quietly. In this case, spontaneity was important because the deteriorating weather meant that the painting had to be finished quickly.

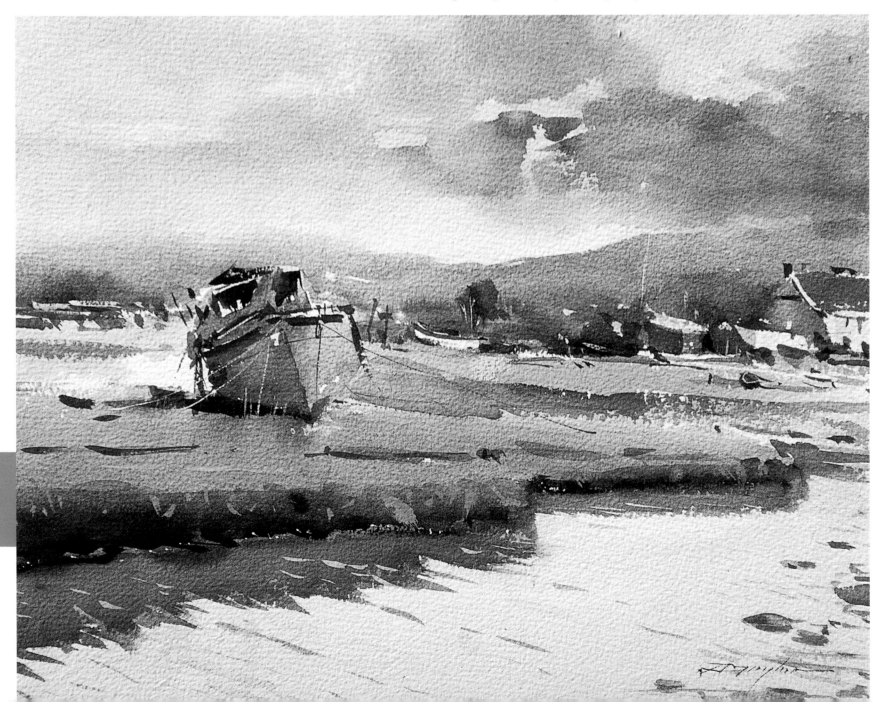

Bringing vitality to street scenes

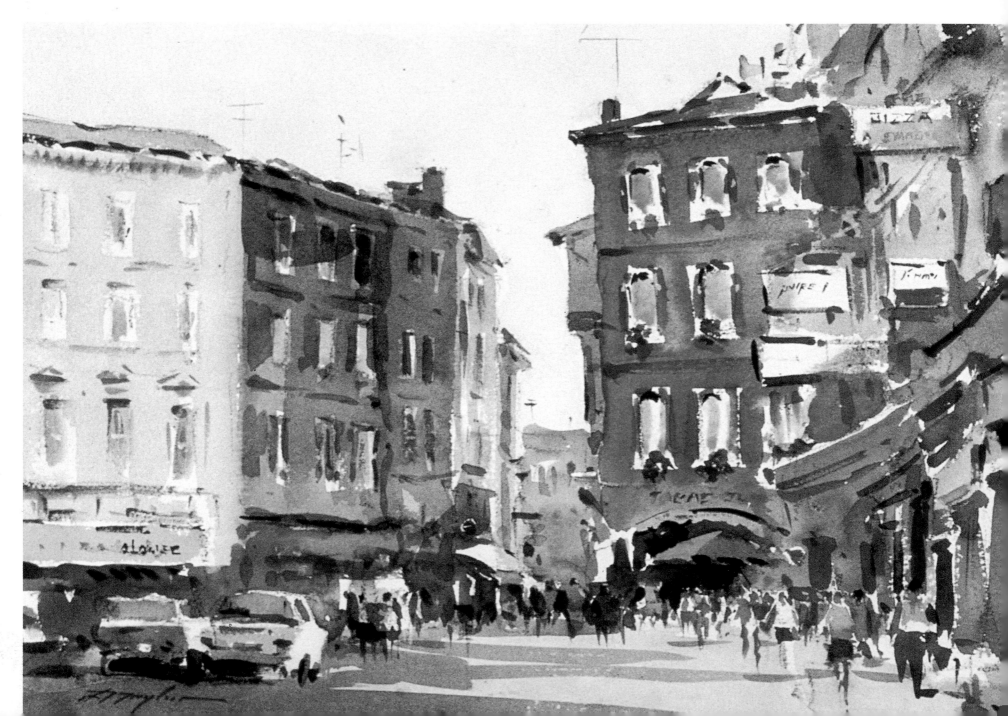

The Blue Blinds, Albi, 11 x 16" (28 x 41cm)

The impact of color brings this scene to life. The blue blinds against the red, although unexpected, lend vitality. Aided by the variety of street signs, the eye is drawn immediately to the green umbrella against the dark background. The waiting cars have been painted with authority and again add to the movement of the scene. The figures, although merely hinted at, are thoroughly convincing. Notice how the shadows have been painted in with single, rapid strokes to give them transparency and spontaneity.

Busy Traffic, 14 x 10" (36 x 25cm)

The mood of this painting is completely different from the scene on the opposite page. Here the street appears much more businesslike and formal. Even the weather seems muted, possibly because of the different selection of colors. I particularly like the wet-into-wet trees and the background running into the loose treatment of the buildings. The white car against the dark background becomes the focal point of the picture. Notice how the color of the red car is repeated elsewhere to preserve unity. The reserved white paper also plays its part in providing vitality.

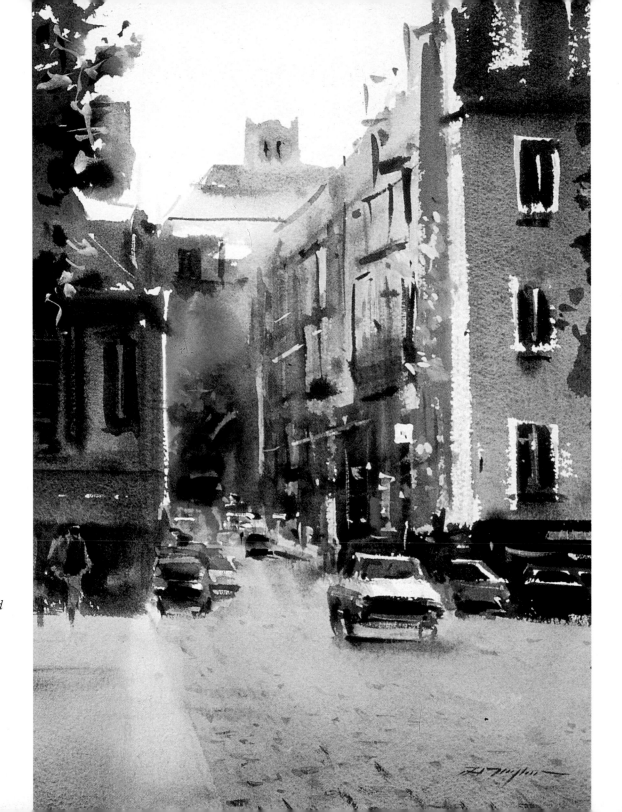

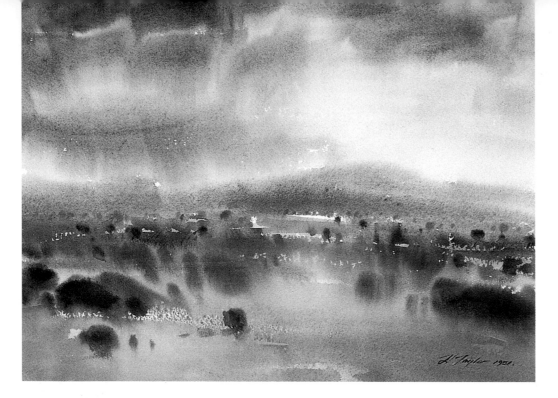

Dancing Shadows, St. Aubin's, 10 x 14" (25 x 36cm)

This painting uses an entirely different approach, but still contains the important ingredient of immediacy. Everything here has a sharp clarity, and yet there is still room for the viewer to use their imagination in its interpretation. David has used the white untouched paper in many areas of this painting and, as he often does, uses strong dark colors adjacent to them, to heighten the impact. The scene contains great examples of alternating color, as in the areas of pink/white and gray/white across the painting. The entire picture is held together by the strong mauve shadows.

Blowing up a Storm, 14 x 18" (36 x 46cm)

This is a wet-into-wet extravaganza — almost a happening! It's enormous fun to do a painting like this. The paper needs to be thoroughly wetted on both sides and you need to attack it with strong color, because the wet paper naturally dilutes everything you put on it. You need to work from back to front, starting with the sky and moving forward to the bottom of the page. Once the main washes are put in, the trees are indicated with paint straight from the tube, which will of course soften when dry.

Summer Mood, Yarra Glen, 10 x 14" (25 x 36cm)

The wet-into-wet here is more controlled and the use of the hard edges changes the mood completely. Here the atmosphere is hot and sunny, which is achieved mainly by the heightened color and variety of tone. The foreground trees have been painted both wet-into-wet, and later, wet on dry. This is a virtuoso performance of great joy, and I would love to have it on my wall.

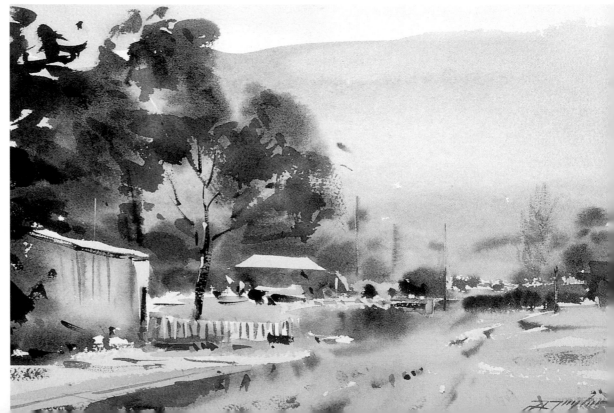

Spontaneity in three different moods

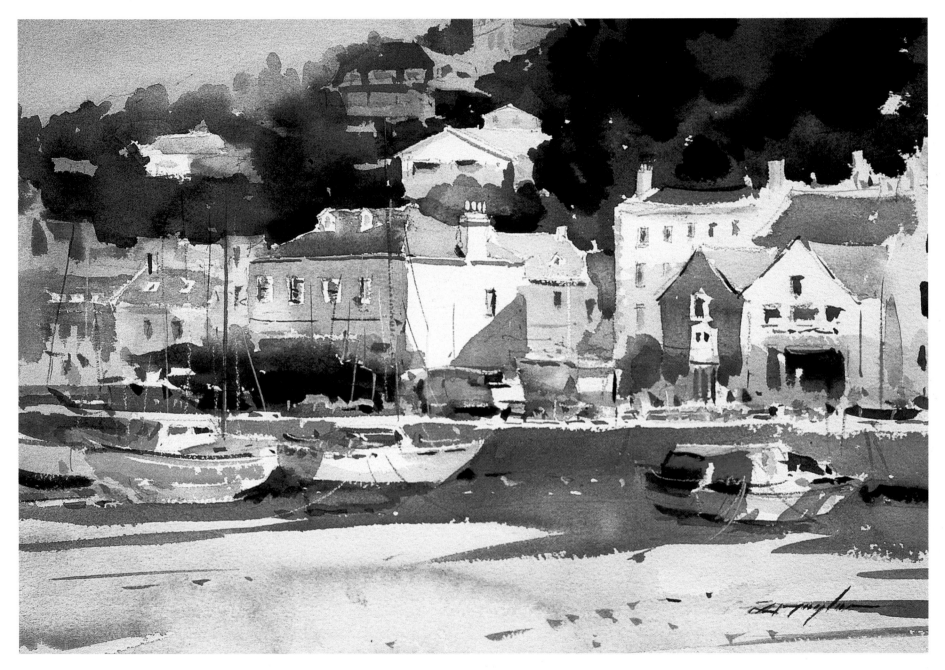

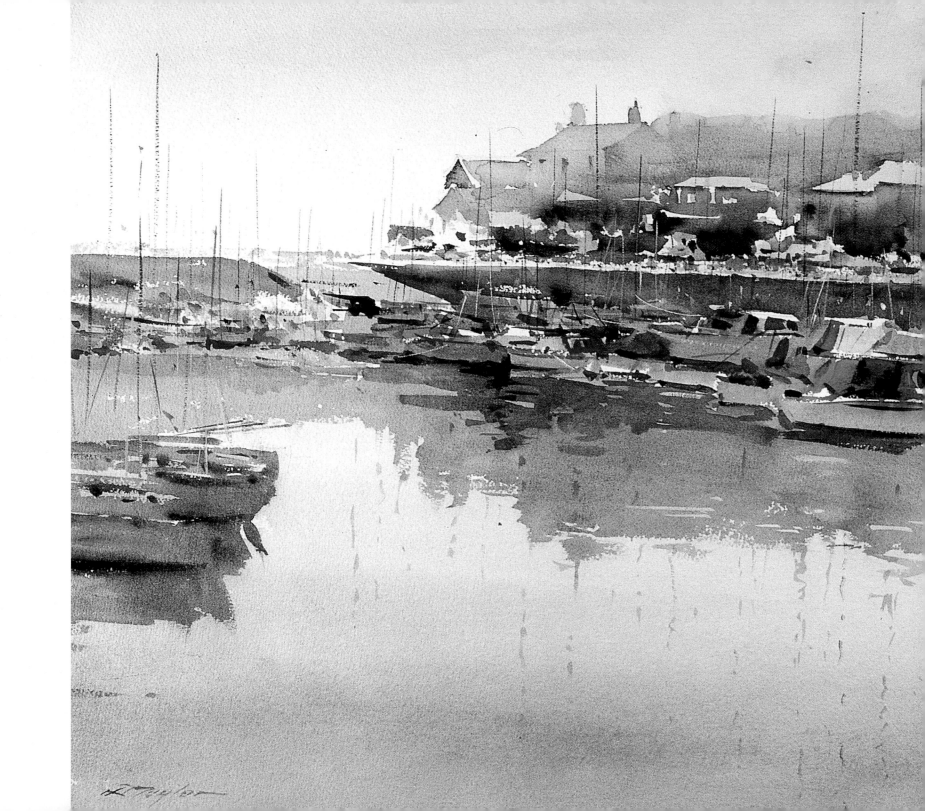

Showcase

This section of the book includes a collection of David Taylor's recent work. Imagine that you are in a gallery viewing David's work, but instead of a fleeting visit, you have all the time in the world to study the paintings. Think of me as your guide who, as we go from picture to picture, will attempt to highlight the points from which we can all learn. It may be color contrast, counterchange, or simply the way our eye is led into the painting. Your involvement is important. You'll probably need to move backwards and forwards from caption to painting several times. This chapter is just as much a learning experience as the rest of the book, and just as much to be enjoyed.

**St. Aubin's Harbor, Jersey,
22 x 30" (56 x 76cm)**

This is a painting about contrasts of technique. The sharp contrast of the boats against the harbor wall immediately attracts the eye because of the rich color, such as we see in the unusual greens in the tarpaulins. As we move further into the painting the houses and background hills create an arc of soft, muted, cool color.

Notice how the small area of ochre on the right of the painting is repeated in the group of buildings in the center background, creating a sense of unity.

Discover the joy of painting in the market place

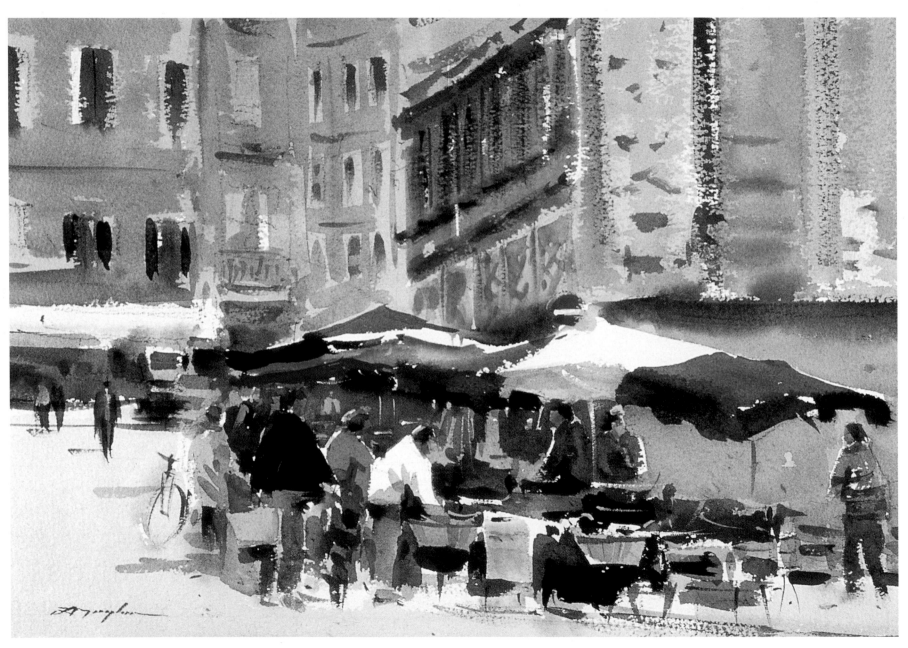

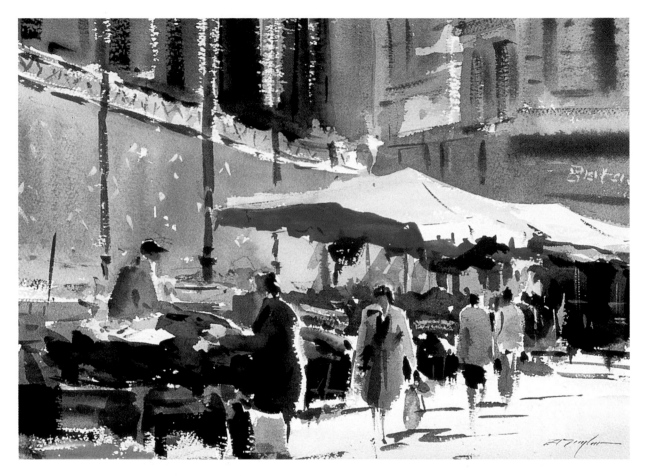

Another corner of the same market we see on the opposite page gives us an unusual contrast with the use of Cadmium Red in half and full strength. Here we see the scene in close up. The composition is excellent. Notice the way the darks are balanced against each other. Although the figures have been loosely indicated, they give a feeling of activity and purpose to the scene. So skillfully are they portrayed that the viewer is left with a strong impression of what the figures are wearing and what they are about.

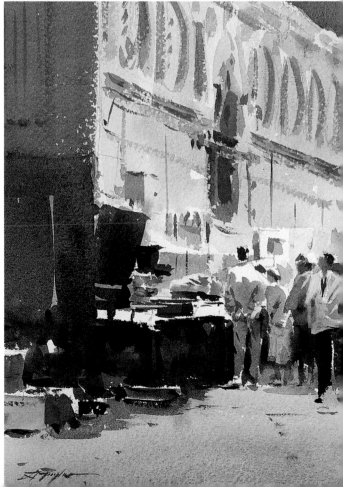

Bargain Hunting — Albi, 11 x 15" (28 x 38cm)

The background buildings here have been treated with soft simplicity and deliberately restrained color. They are used merely as a foil for the foreground scene. The foreground has been put in with great generosity. There is great richness of color and contrast. First look at that blue — it's almost full strength. There is spontaneity in the stance of the figures, showing their eagerness to find a bargain. Notice how David has used the white paper to great effect.

What's Cooking, The Market, St. Peter Port, 15 x 11" (38 x 28cm)

In contrast to the other two scenes, here we have an indoor market. This is a strong L-shaped composition with the vertical column on the left being balanced by the figures on the right. It's so important to be able to indicate convincing figures, while at the same time create them with the fast, free strokes that are essential in providing the feeling of spontaneity and movement. There are no shortcuts. Only after months of practice will you achieve that apparently nonchalant approach. Notice too, the richness and variety of color in the really dark passages — it's so easy to be lazy and make them boring and monotonous.

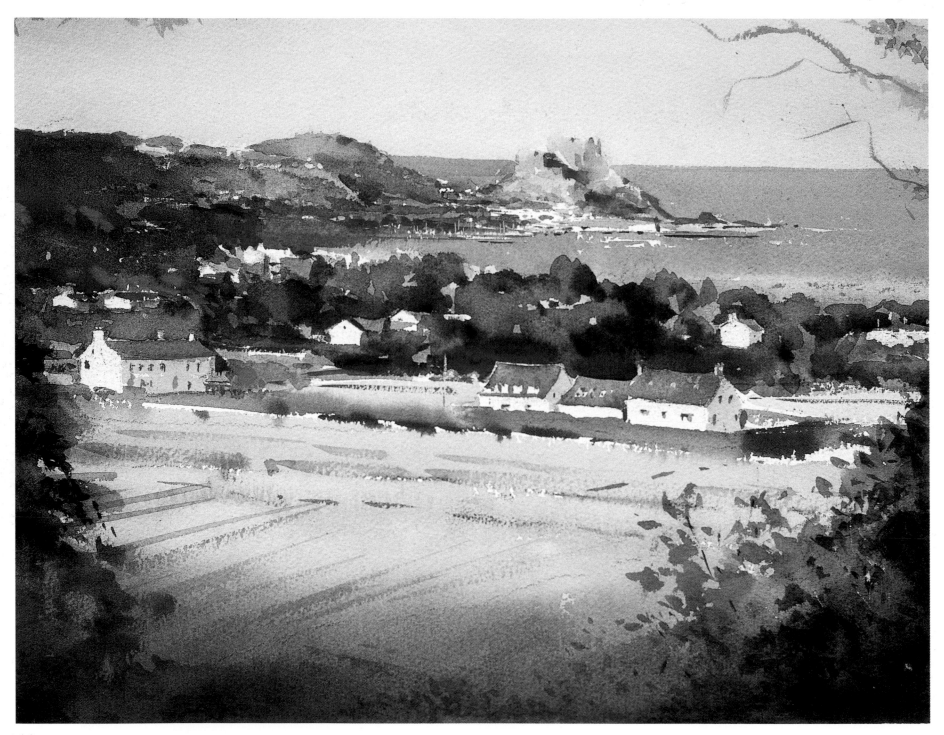

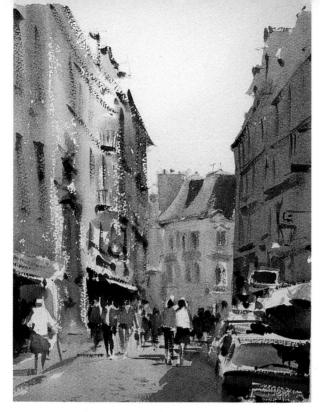

A Walk in St. Malo, 14 x 10" (36 x 25cm)

What excites me about this painting is the way that David has indicated the foreground area with such authority. There's also a great sense of recession achieved by cooling down the colors towards the back of the picture. The untouched paper is used in a masterly way. Notice how each of these areas has a dark tone adjacent to it, which lends freshness and excitement to the painting. Notice the simple way in which dry brush has been used to indicate the windows.

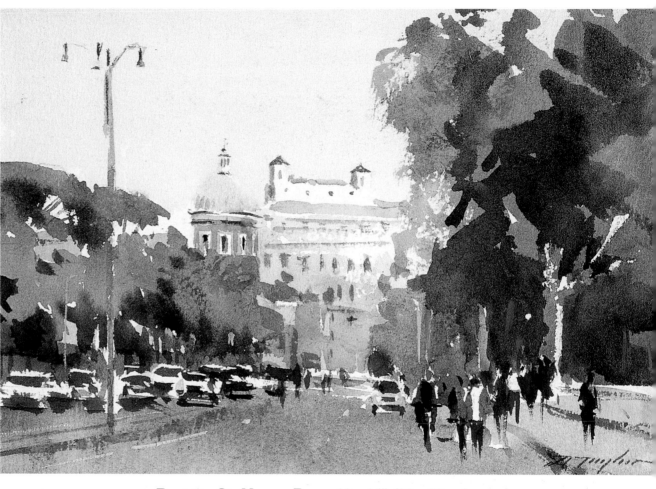

Jersey Landscape, 11 x 15" (28 x 38cm)

This distant view of Jersey is beautifully framed by the foreground trees. The eye is led into the distance by the various layers of tone and color. Notice how the roofs of the buildings are counterchanged by the dark trees. The overall impression is of a warm day in summer viewed from the shade of the trees just outside our vision. The painting is given added interest by the cool colors in the distance.

Route to St. Marco, Rome 11 x 15" (28 x 38cm)

This painting is about the rich contrasts of strong greens in the trees with the darks and lights of the traffic and pedestrians. Look at the way the cars on the left are merely dark and light shapes against each other, and yet they are completely convincing. The background buildings have been put in with an interesting subtlety of color. David doesn't use masking fluid, but manipulates untouched paper with freedom and incredible skill.

111

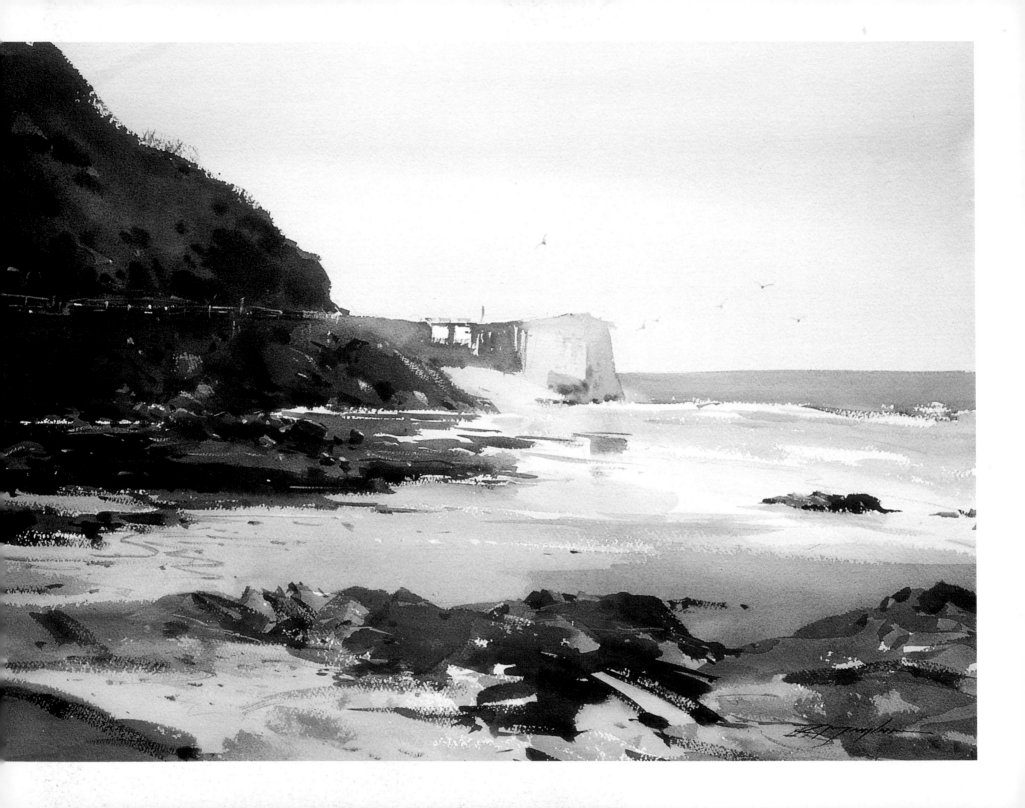

Down to the Sea, Greve De Lecq, Jersey,
10 x 14" (25 x 36cm)

Here we see strong use of dry brush in the foreground, painted in rich, warm colors. The dry brush has been dragged across the surface leaving these exciting stippled strokes. The same technique has been used in the distance, but this time to convey the impression of highlights on water. The strong headland on the left of the painting has been indicated using a loaded brush, yet the area retains much subtlety of color. The foreground mauves and teracottas harmonize beautifully with the adjacent light reds, adding a sense of unity to the scene.

Rounding a Corner, Le Bugue,
14 x 10" (36 x 25cm)

This is one of my favorite street scenes — it gives me a warm and satisfied feeling each time I look at it. This may be due to the way the strong, warm mauve shadows of the street contrast so well with the subtle colors of the buildings. The eye is taken immediately to the cream colored car beautifully contrasted against the dark shop window. As we move further back into the scene, notice how at the end of the street the tones are more subtle and delicate, giving a feeling of distance. The cars are important. Try covering them up and notice how the picture immediately loses some of its vitality. The figures too, are well placed and have their own part to play.

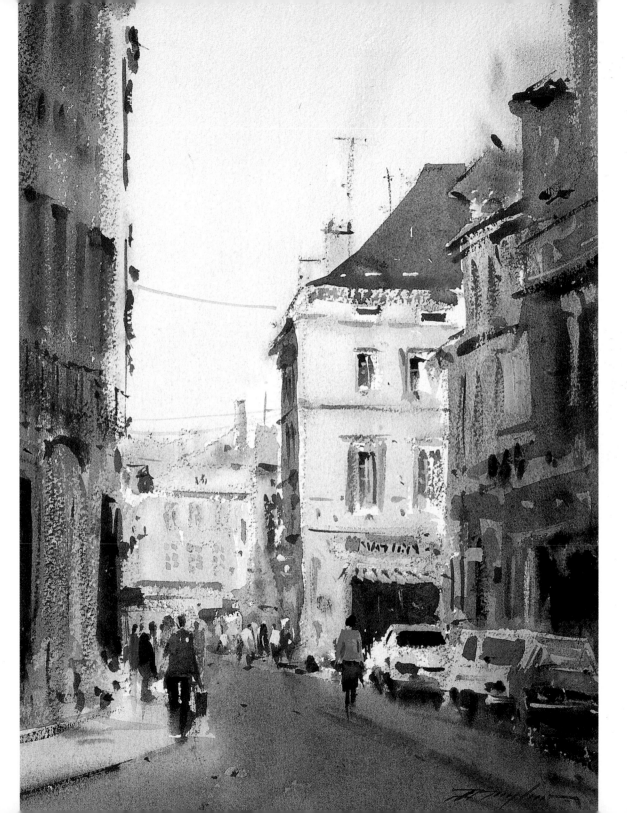

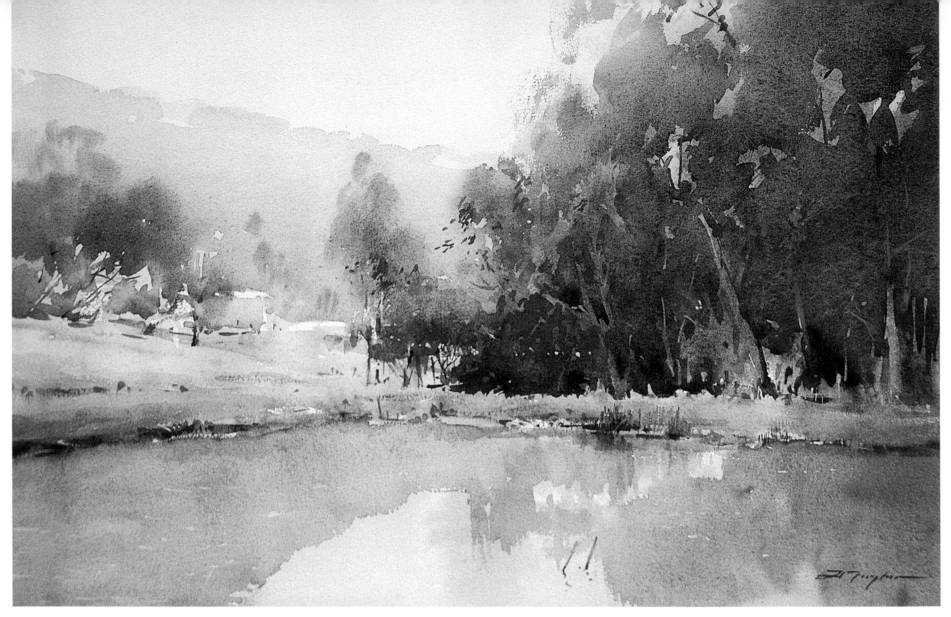

Smiths Gully, Tarentaal, 14 x 21" (36 x 53cm)

River Barges, Paris, 14 x 21" (36 x 53cm)

The foreground water has been treated with great simplicity. The brushwork has given it the mood of a busy and constantly disturbed stretch of river. The barges and other river craft are economically, but well indicated, and enliven the scene with their rich blues and reds. As the scene recedes the trees become closer together, giving a strong sense of distance. Notice the delicacy of the bridges and how they contrast with the robustness of the barges.

Creating different moods in water

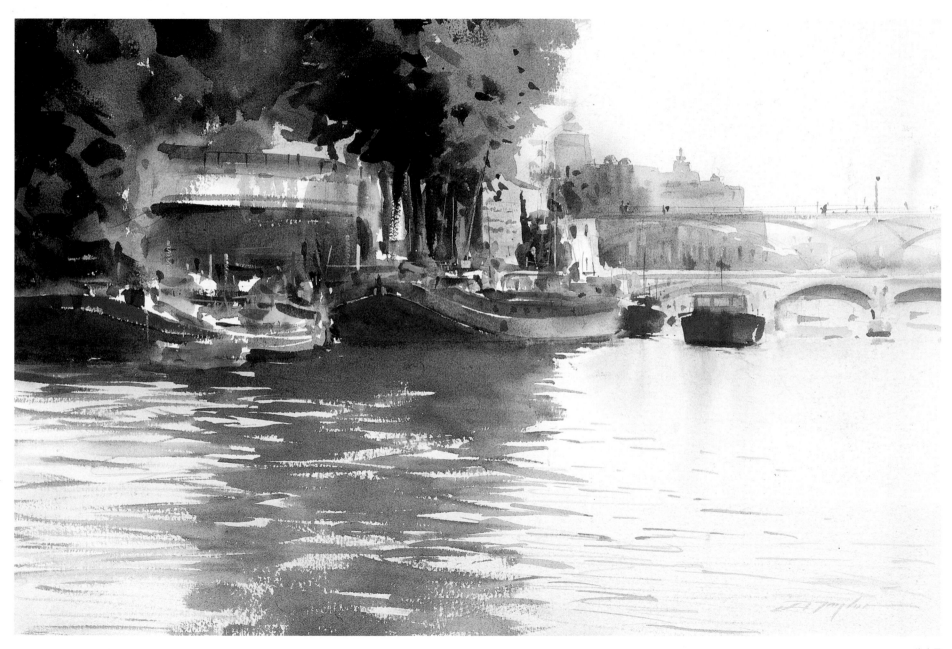

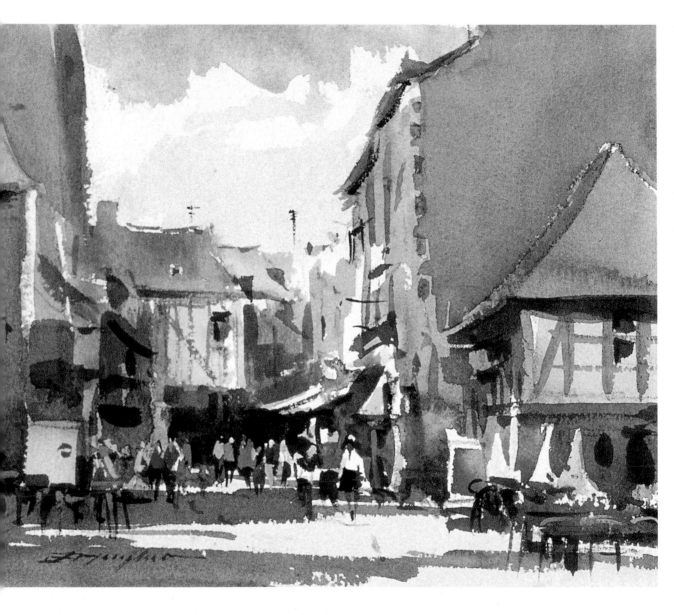

**Sunlight and Shadow, Dinan,
10 x 14" (25 x 36cm)**

The whole painting seems to revolve around the bright yellow wall in the middle distance. This is because David has surrounded it with strong, warm darks. The darks are important because they show up the awnings and the figures. The treatment here is loose and fresh throughout, yet there is a strong impression of a medieval town. As you look at the painting you'll notice added touches of strong, rich color, that enliven the painting considerably. The foreground tables and chairs are so authentic, while the foreground shadows are put in swiftly with dry brush.

Fisherman's Haven, Chioggia, ▶
10 x 14" (25 x 36cm)

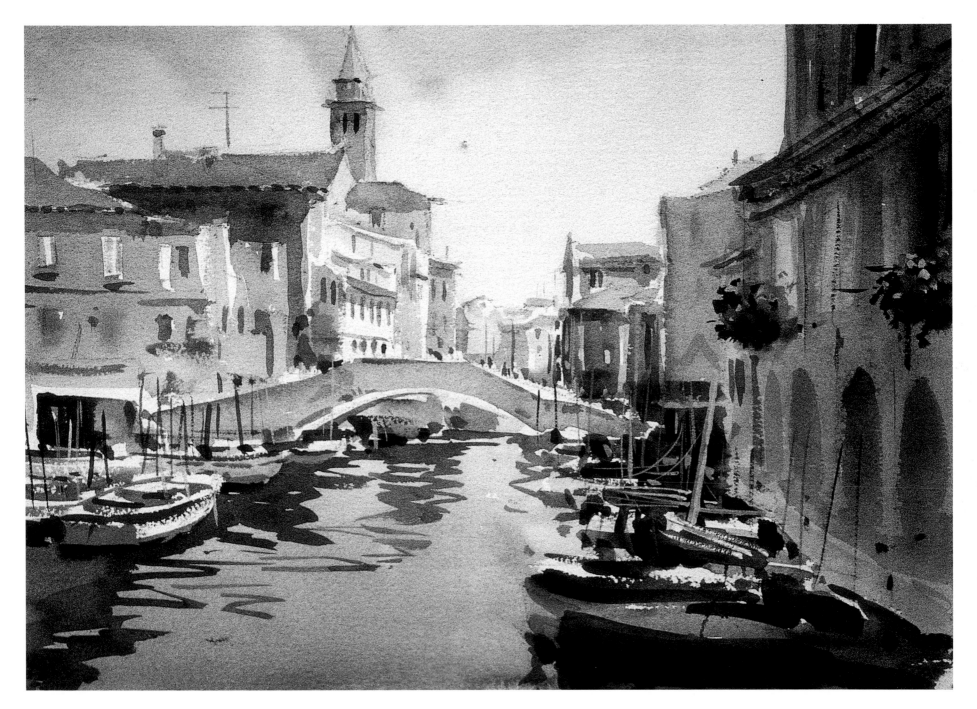

How bright spots of color can add excitement

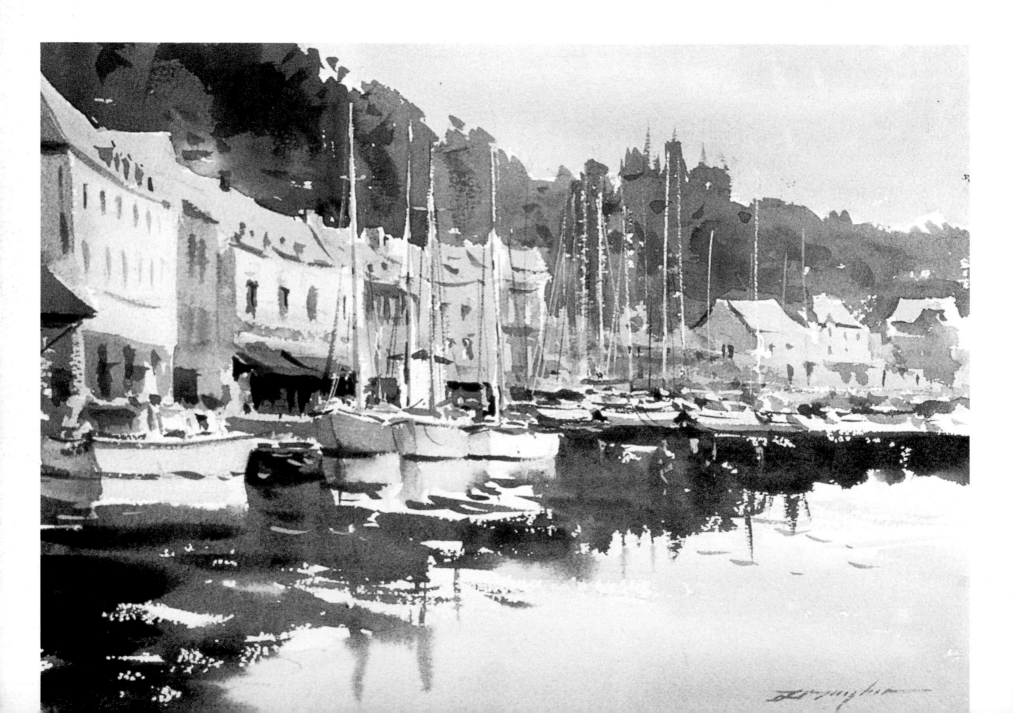

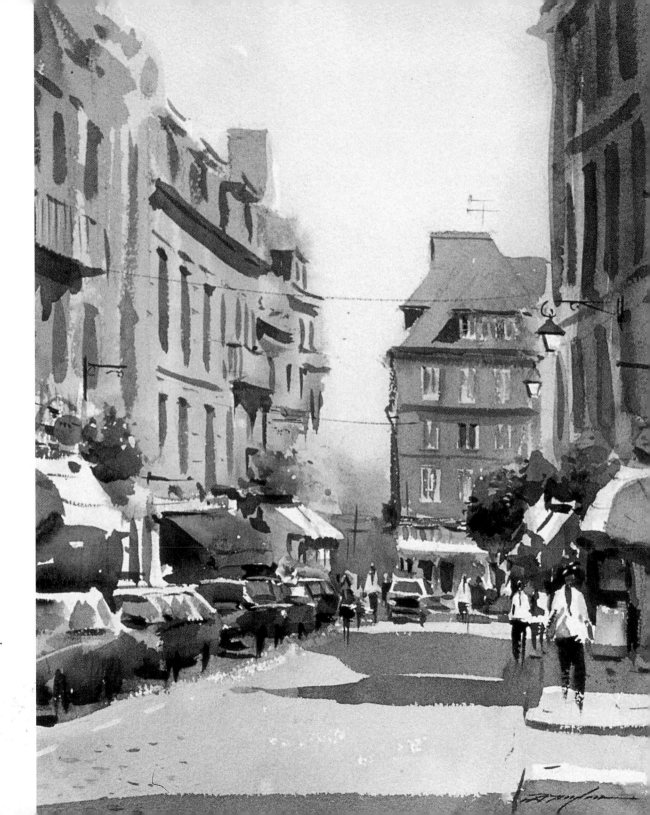

Moorings, Dinan, 11 x 15" (28 x 38cm)

This is a strong and vigorous watercolor, with the background trees used to pick out the profile of the roofs. The reflections of the trees are painted very loosely with real courage, and they indicate water, with just the right amount of movement. The isolated patches of bright blue and red are in just the right place to make that area the focal point. Just try covering them up with your finger and notice how much of the impact of the painting is lost without that color.

Out Come the Blinds, St. Malo, 15 x 11" (38 x 28cm)

By now you'll have realized that street scenes are one of David's favorite subjects, and they show how well he can suggest so much with so few strokes. For instance, look at that row of cars and the apparently casual stroke made for each. However, we can really learn from the odd bright touches of orange, blue, and yellow scattered among the more subdued colors of the buildings. Notice too, that the shadows across the street are not dull gray, but a subtle mauve. Don't you love that casual young man in the white shirt on the right?

Tackling panoramas

Tortevel Skyline, Guernsey, 11 x 15" (28 x 38cm)

This painting is all about a distant town with light shining on the rooftops. This was done by using fairly strong color, leaving untouched paper for the roofs. The impression is of one of those very clear days after rain where there is not much recession in the distance. However, by using warmer, darker colors nearer the front, everything still works. Notice the very subtle pink of the foreground roof, complemented by the adjacent green grass and the road, which always helps to take the eye into the painting.

Rolling Hills, Smiths Gully, 11 x 15" (28 x 38cm)

This painting, near David's home, gives an impression of enormous depth and space. It is a picture of high summer, the nearby golden hills are contrasted against the blue and mauve of the unending distance. This painting was begun at the back wet-into-wet, merely hinting at the various planes and woods. Then the rich foreground greens, are indicated with more power, more paint, and more detail. It is really worth practicing for yourself. The far distance is very subtle and the water content is very sensitive.

Painting a subject that goes back miles, while exciting, presents its own difficult challenge. On a flat piece of paper you've somehow got to give the impression of enormous space and depth. It's all done with warm and cool colors and tone, working from the furthest distance to the nearest foreground.

The Sweeping Coastline of San Juan, Jersey, 11 x 15" (28 x 38cm)

Once the sky is completed the distant horizon is indicated by quick, simple strokes of dry brush color to suggest texture. Moving forward the trees and counterchanged houses are in darker, but comparatively cool color. From there to the foreground the color is warmed up with richer greens and pinks. The shoreline itself has a strong S-shape, which takes the eye strongly into the distance. Notice how the darkest, richest green has been restricted to the foreground.

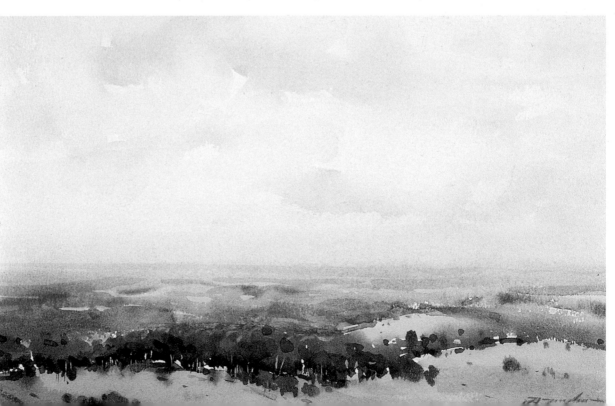

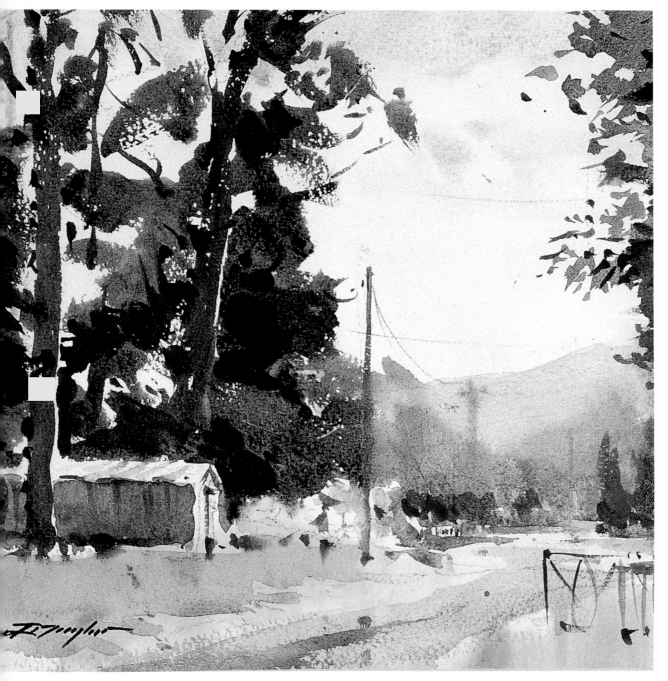

Pathway through the Pines, Yarra Glen,
15 x 11" (38 x 28cm)

This was painted in one of Australia's wine regions and is all about stark contrasts. The rich, dark pine trees in the foreground are exciting, as they contrast strongly against the white hut. The white edges to the trunks are also important, but the trees really form a frame to show the exquisite colors and treatment of the distant scene, which is masterly in its simplicity and subtlety. Looking back to the pines on the left, the way they have been strongly indicated with so few strokes is a lesson for us all.

Life in Chioggia, ▶
11 x 15" (28 x 38cm)

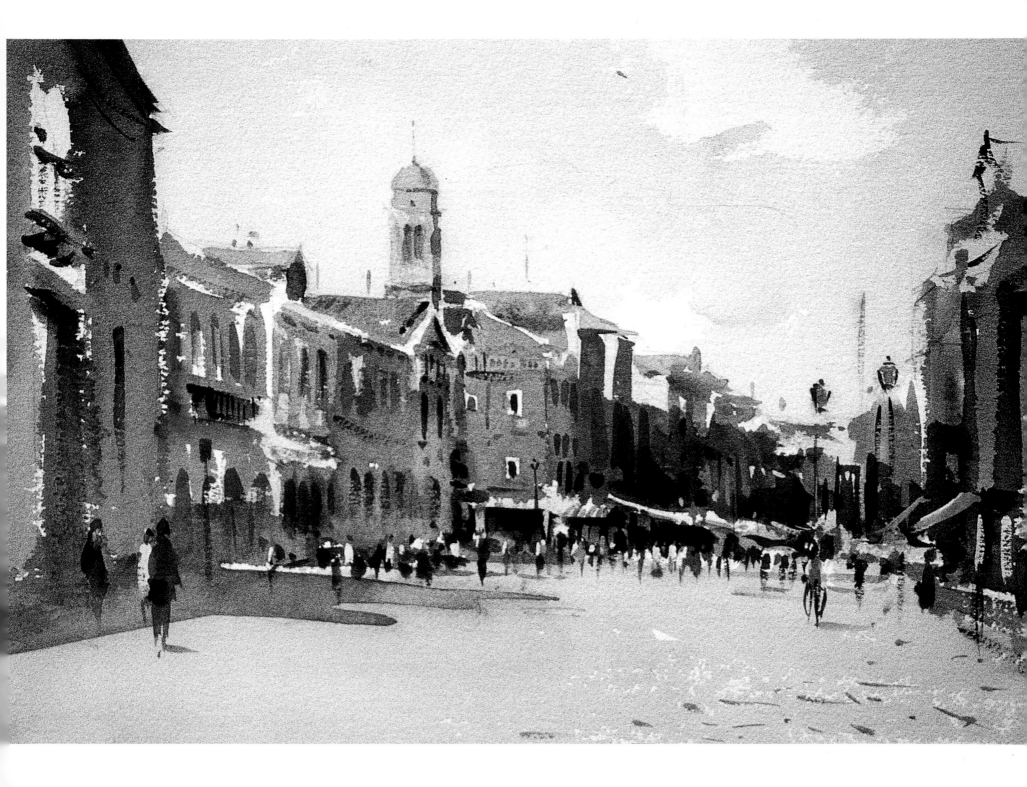

Painting in high and low key

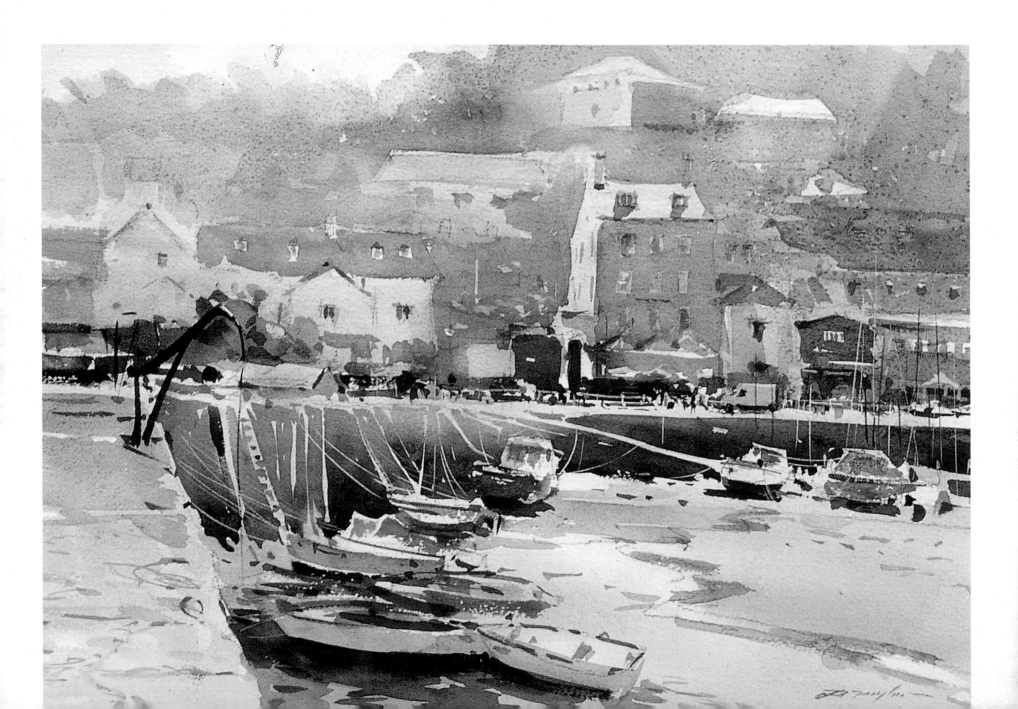

All Tied Up, St. Aubins, Jersey, 11 x 15" (28 x 38cm)

This is a very high key painting using thin color washes and a very close range of tonal values, especially in the background, which evokes the feeling of looking into the light on a misty morning. Note the way the guy ropes holding the boats link the background to the foreground. The harbor wall on the far left takes the eye into the painting and along the quay where David has portrayed the strongest contrast.

Reflections, Salcombe, 15 x 11" (38 x 28cm)

This is a fairly low key painting in which David has used a very limited palette of four colors — French Ultramarine, Cadmium Orange, Burnt Sienna and Cobalt Blue. He has managed to convey a sense of distance and mystery here. However, the way he has handled the water deserves attention — the treatment is more complex than usual. He has first gradated the general surface to give depth, and some of the darks have been put in with soft wet into wet. After allowing the surface to dry, he has added further dark strokes, including some dry brush in the foreground.

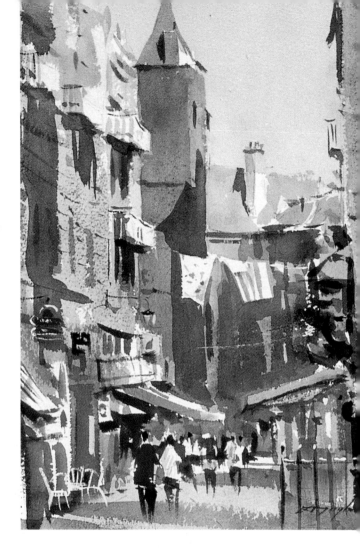

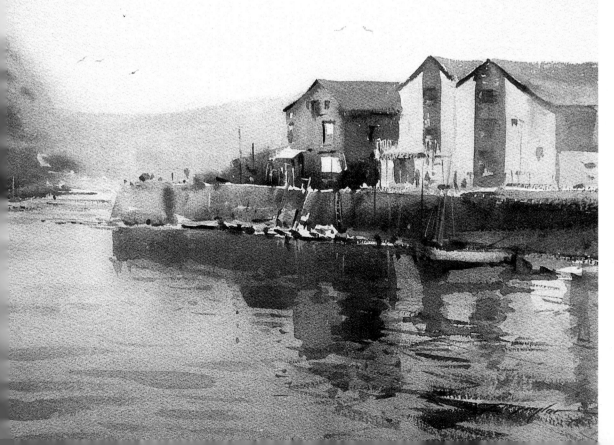

Passage De La Grande Hermines, St. Malo, 11 x 15" (28 x 38cm)

What makes this painting so special is the way David has exploited the light shapes against the dark. Look at the tops of the awnings, the balconies on the left, and most of all the washing hanging across the street. This has been done freely without using masking fluid. Notice that when he has added the bright colors each one is repeated in another part of the painting to achieve unity. Look at the dark red on the figure and the bright green of the awning. The white chairs have been added with gouache.

125

Getting maximum power and richness in watercolor

Clouds Over Elizabeth Castle, Jersey, 11 x 15" (28 x 38cm)

This a very powerful painting of contrasts. David has used a subtle background of wet-into-wet sky and on top of this he has placed the strong silhouetted shape of the castle with all its color and counterchange. In front of this he has created masses of texture and light indicating the rocky out-crops at low tide. This latter is an excellent example of the maximum use of the dry brush technique. It's really worth studying and experimenting with.

Fishermans Haven, Chioggia, 11 x 15" (28 x 38cm)

This fishing port just south of Venice has long been a favorite venue for artists from all over the world. Both David and I have taught watercolor there for "International Artist" magazine. Everything happens in this one-mile long canal. Beautiful buildings with arches, graceful bridges, and hundreds of moored fishing boats. It almost stops your heart when you first see it. The shapes of the boats seem to merge with the stonework of the buildings. I feel David has completely captured the bustle, sparkle, and magic of the port with very limited strokes.

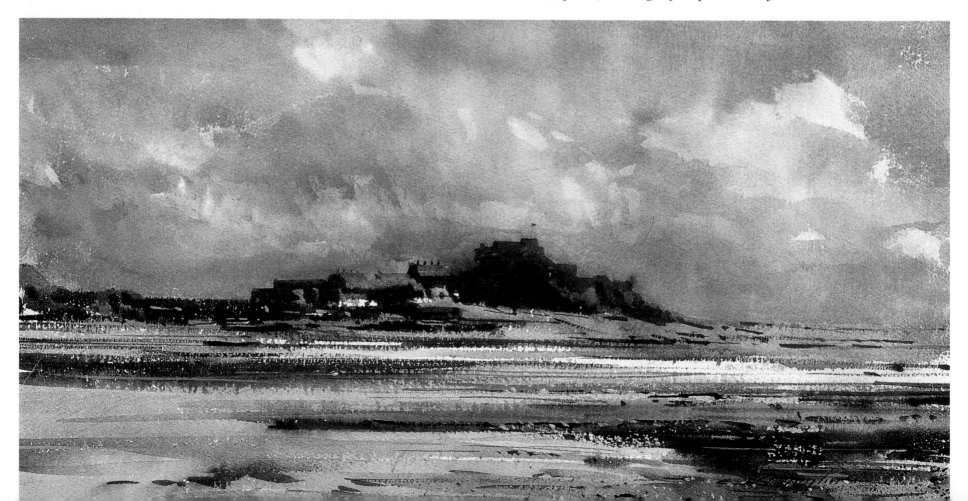

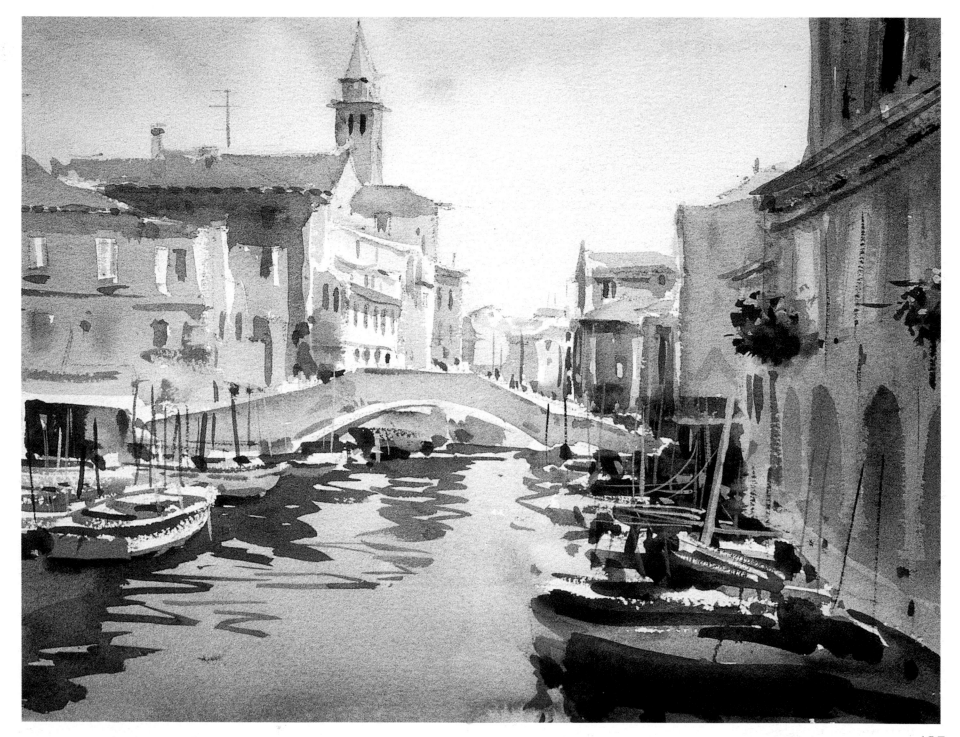

About the artist

David Taylor and his artist wife, Diana, seem to have the best of both worlds. They have a lovely French Provincial style house set on a hilltop overlooking miles of rolling land, where, in the early morning kangaroos feed around the house and maybe fifteen miles away, on the far horizon, you can just see the distant skyline of Melbourne.

Their home has a large studio and ample accommodation for the artists who flock to workshops to learn the Taylor magic year round.

David, has had a long association with *Australian Artist* and *International Artist* magazines, and leads *International Artist Painting Workshop Vacation* tours to Europe for them to such wonderful places as Tuscany, Provence, Sicily and the French Riviera.

He also holds regular solo exhibitions in England, in the English Channel islands of Jersey and Guernsey, as well as in many prestigious Australian galleries.

It is an ideal life for an artist who is recognized

internationally for the quality of his work.

David was born in Melbourne, Australia in 1941. Like many who display natural talent, he wanted to pursue a career as an artist. This dream was viewed by his parents as unlikely to provide financial security, so David set about becoming an artist through a more indirect route. He served a six year apprenticeship with a printer as a color etcher and engraver, studying at the North Melbourne Printing School of Graphic Arts. He applied what he learned about color and composition to his own work and when his watercolors began to attract attention, his employer encouraged his ambitions, eventually buying a group of his paintings before wishing him well in his new career.

It was not long after turning professional that David was invited to join the prestigious Victorian Artists Society, where he later became a Fellow after winning most of their prizes and serving on the council for eight years. He was VAS Artist of the Year in 1976, 1980 and 1989. Then, in the early 1980s, he received the Australian watercolorist's ultimate accolade when he was elected to the elite Australian Watercolour Institute.

To date, David has won over 100 awards, including the Camberwell Rotary Travel Grant Scholarship. David's most recent success is the coveted Gold Medal and US$10,000 for Best of Show in the 2002 Herald Sun Camberwell Rotary Art Show, Australia's biggest realist art show,

which attracts enormous crowds and entries from the country's finest artists. David is also in demand as a respected art show juror.

Among his notable achievements is a Distinguished Leadership Award for Outstanding Services to Watercolor and Teaching (International Directory of Distinguished Leadership), and a Certificate of Merit for Distinguished Service to the Community.

David's work has been featured countless times in *Australian Artist* and more recently in *International Artist* magazine.

This is his first book.

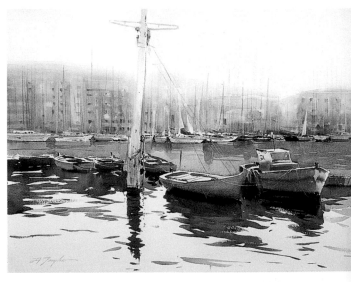

This painting won the Gold Medal and Best of Show in the 2002 Herald Sun Camberwell Rotary Art Show